COLOR ME
TO
SLEEP

Quarto is the authority on a wide range of topics.

Quarto educates, entertains and enriches the lives of our readers—enthusiasts and lovers of hands-on living.

www.quartoknows.com

Text © 2016 by Lacy Mucklow
Illustrations © 2016 by Angela Porter

First published in the United States of America in 2016 by
Race Point Publishing, a member of
Quarto Publishing Group USA Inc.
142 West 36th Street, 4th Floor
New York, New York 10018
www.quartoknows.com

10 9 8 7 6 5 4 3 2 1

ISBN 978-1-63106-237-7

Editorial Director: Jeannine Dillon
Managing Editor: Erin Canning
Project Editor: Jason Chappell
Cover Design: Jacqui Caulton
Interior Design: Rosamund Saunders

Printed in China

This book provides general information on various widely known and widely
accepted images that tend to evoke feelings of rest and calm in individuals.
However, it should not be relied upon as recommending or promoting any
specific diagnosis or method of treatment for a particular condition, and it
is not intended as a substitute for medical advice or for direct diagnosis and
treatment of a medical condition by a qualified physician. Readers who have
questions about a particular condition, possible treatments for that condition,
or possible reactions from the condition or its treatment should consult a
physician or other qualified health care professional.

COLOR ME TO SLEEP

Nearly 100 Coloring Templates to Promote Relaxation and Restful Sleep

Lacy Mucklow, MA, ATR-BC, LPAT, LCPAT

Illustrated by Angela Porter

Afterword by Alanna McGinn

Race Point
PUBLISHING

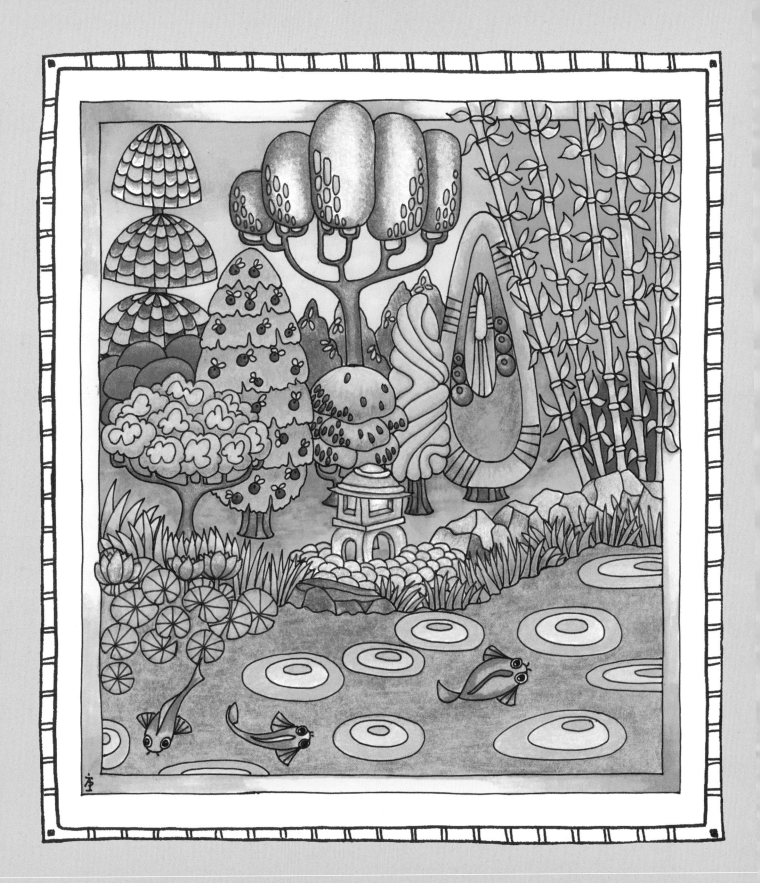

CONTENTS

Introduction 7

Chapter 1: Peaceful Environment 11

Chapter 2: Cozy Comforts 47

Chapter 3: Quiet Getaways 83

Chapter 4: Relaxing Routines 115

Chapter 5: Sleep Scenes 151

Chapter 6: Fantasies and Dreams 183

Afterword by Alanna McGinn 206

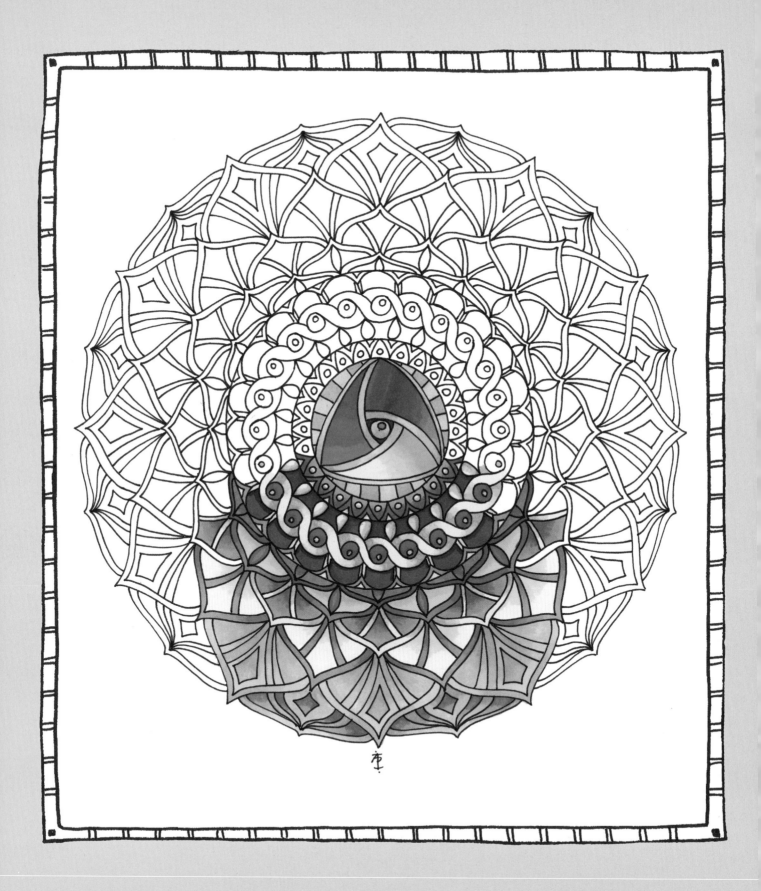

INTRODUCTION

Why make a coloring book for adults? As children, many of us enjoyed coloring our favorite characters or scenes in books with our trusty pack of crayons. But as we got older, added responsibilities came along, which pushed aside things we used to do for sheer enjoyment.

One of the great things about coloring is that it is highly successful for everyone—even if you lack artistic instruction or experience—and it can be as nuanced or generalized as the colorer wishes. Having guidelines eases performance anxiety, and being able to add your own colors helps make the experience more personal. The act of coloring can also be meditative in and of itself, bringing about mindfulness just through the simple act of picking up a colored pencil or crayon and focusing your creativity and thoughts on a single coloring exercise.

Despite what you may have learned about art and color in your lifetime, there is no right or wrong way to use this book; you have the freedom to color it in however you wish in whatever way works best for you. Conceptually, in "Color Me to Sleep," the chapters are divided into six themes that are associated with achieving restfulness either in preparation or in practice. Considering aspects of good sleep hygiene, such as having a comfortable and quiet environment, establishing

and keeping a bedtime routine, visualizing your perfect sleep scene, and imagining positive and whimsical fantasies and dreams, can help facilitate better sleep. The images included to color are intended to help your mind to focus on the things that may aid in falling asleep: comfy beds, cozy linens, warm beverages and fireplaces, serene environments, peaceful nights, starry skies, sleep havens, hot baths, journals or books, whimsical fantasies, and nocturnal icons. Focusing on such images that foster or exemplify sleep—or positive bedtime routines—can help you to incorporate them in a practical way into your own life. Even coloring in this book can become a nighttime routine that can help you to step back from the day's events and relax before going to bed. Visual inspiration and the act of coloring combined with the carefully chosen subject matter can assist in influencing the way we think and feel. This book seeks to bring you into a positive space to help foster self-care for more effective sleep, one small step at a time.

We realize that what inspires relaxation in people can run the gamut even within "universal" themes, so we have included a variety of images within each chapter so that at least some of the pieces connect with you personally. The designs are intended for adult sensibility and dexterity rather than for children, and include actual scenes (or variations thereof) to encourage attaining serenity. Some are more abstract in nature so that you may enjoy the intricacy of the patterns themselves, as many of us do. Most importantly, this book is about helping you suspend your mental energies for a short while and hone in on something else that aims at promoting well-being.

At the end of each chapter, a blank panel has been included so that you can have a chance to think about and draw (and color) an image that is unique to you—this will make the coloring experience even more personal and will hopefully keep you mindful about things and experiences that you find relaxing. You may find that engaging with this book in a regular routine may be particularly helpful for you, especially to use at night as a part of your winding-down routine before bedtime. This book is intended to bring about a more peaceful and relaxed emotional state as a way to help you self-soothe for better sleep; however, it is not meant to replace the services of a professional counselor if more direct intervention and personal guidance is needed. We hope that you enjoy this book and that it helps you find a way to color yourself to sleep!

COLORING TIP

Cool colors (such as blues, greens, and purples) are considered to have calming qualities, while warmer colors (such as reds, oranges, and yellows) have more activating qualities. In addition, bright colors also tend to have more energy while pastel or tinted colors tend to communicate softer energy. Darker colors or shades usually indicate lower energy. The most important thing when coloring is to figure out which pleasant and soothing colors might help with stressors that you need calming from, or you might want to use colors that are more energetic to help promote a positive growth or outlook, and then try to incorporate them into your artwork.

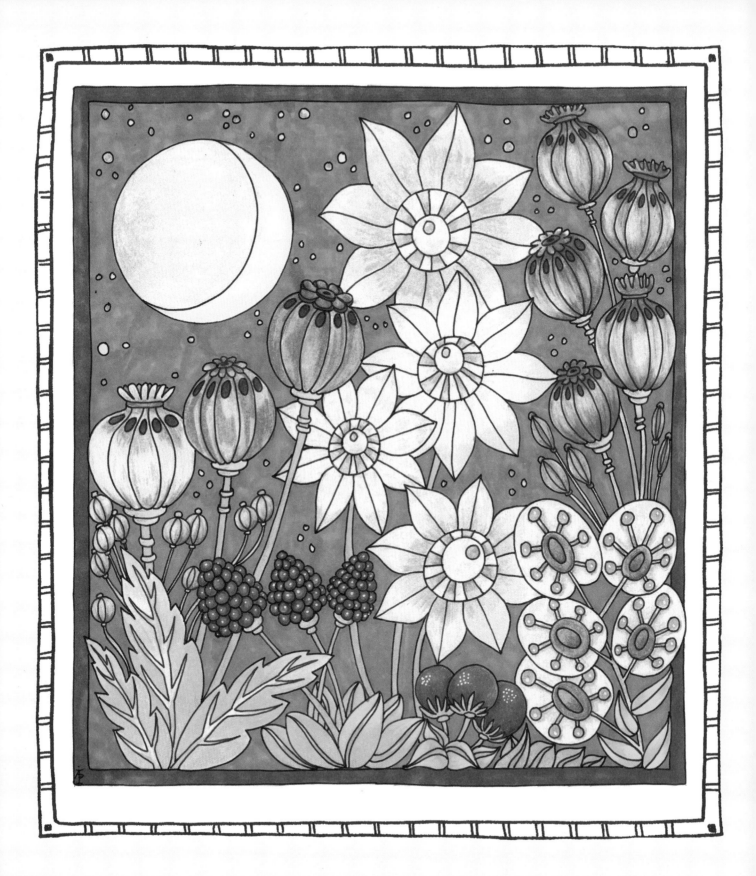

Chapter 1

PEACEFUL ENVIRONMENT

Surrounding ourselves in a peaceful environment can help us sleep better. Depending on where you live, you may find that leaving the windows cracked during temperate weather to feel a nice breeze or to hear the soothing sounds of nature can be helpful in providing restful sleep. Living in an urban area can make a peaceful night a bit more challenging, but there are some things you can do to help facilitate it, such as using blackout and soundproofing window treatments or white noise machines, or envisioning a clear, quiet night outdoors. Maintaining a dark, quiet bedroom with minimal distractions and creature comforts can also facilitate your sleep cycle. The following images promote scenes and ideas that will help you envision sleeping in a peaceful environment and promote restful sleep, including images of the moon and stars, comfy beds, starlit quaint streets, and celestially themed mandalas. A blank panel is included at the end of the chapter to encourage you to draw and color your ideal serene environment.

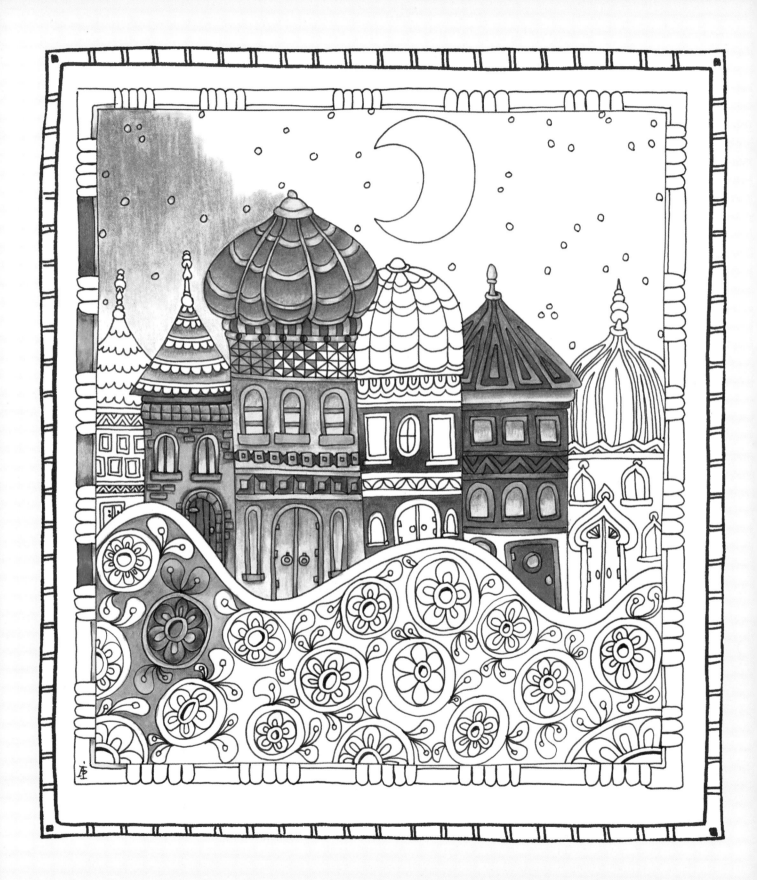

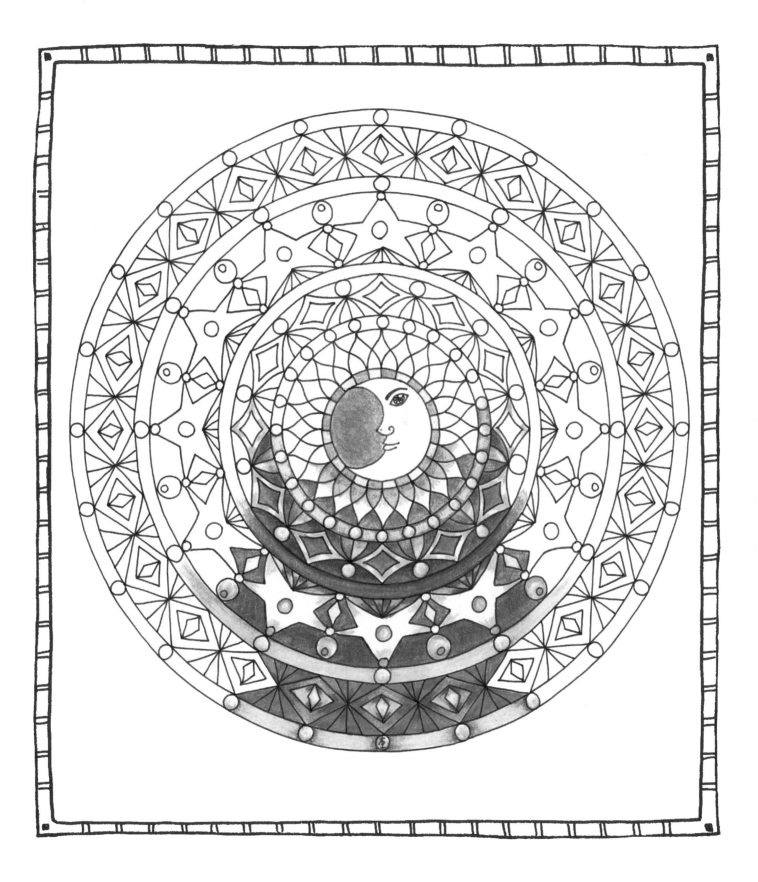

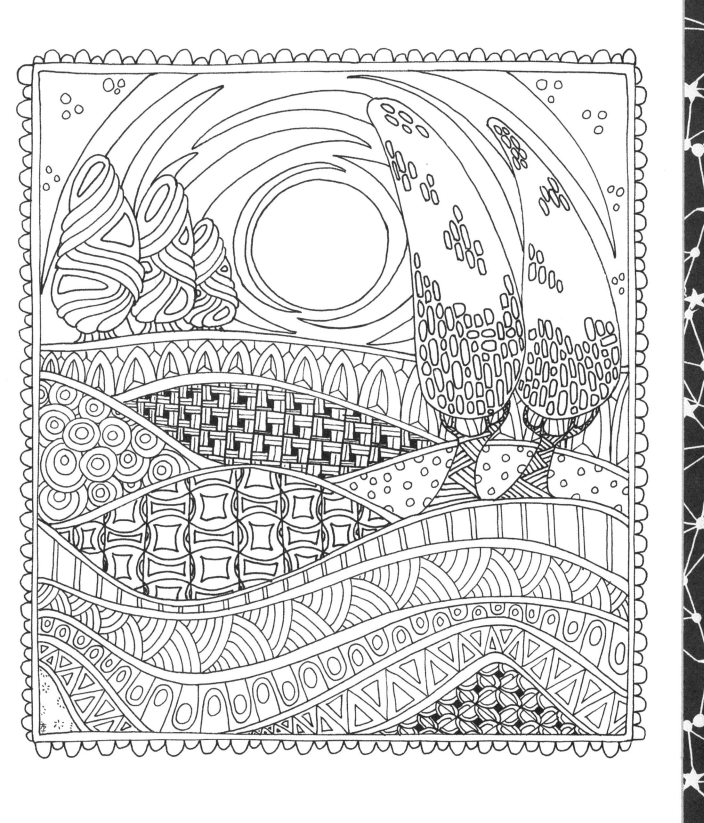

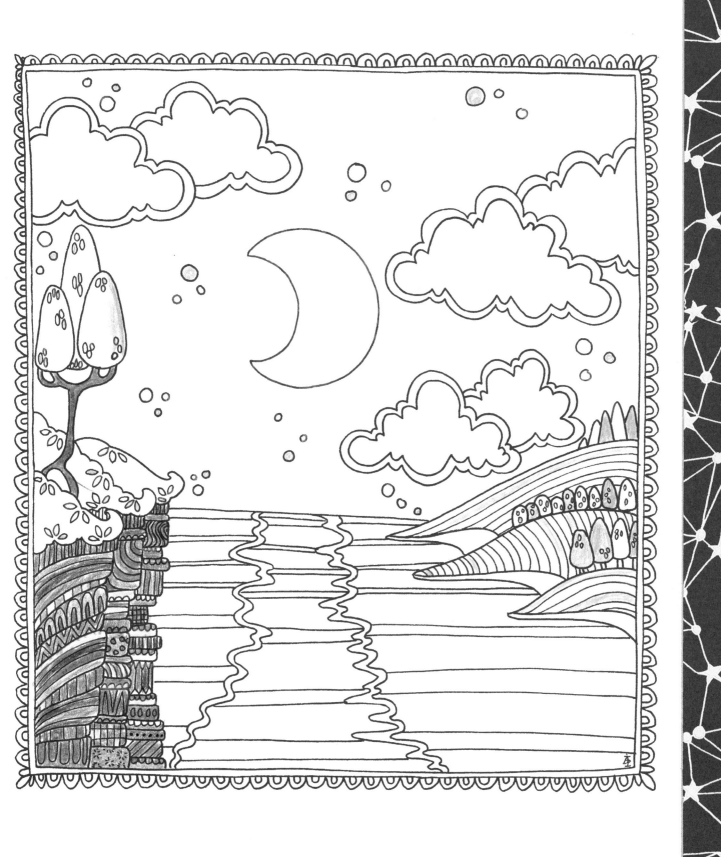

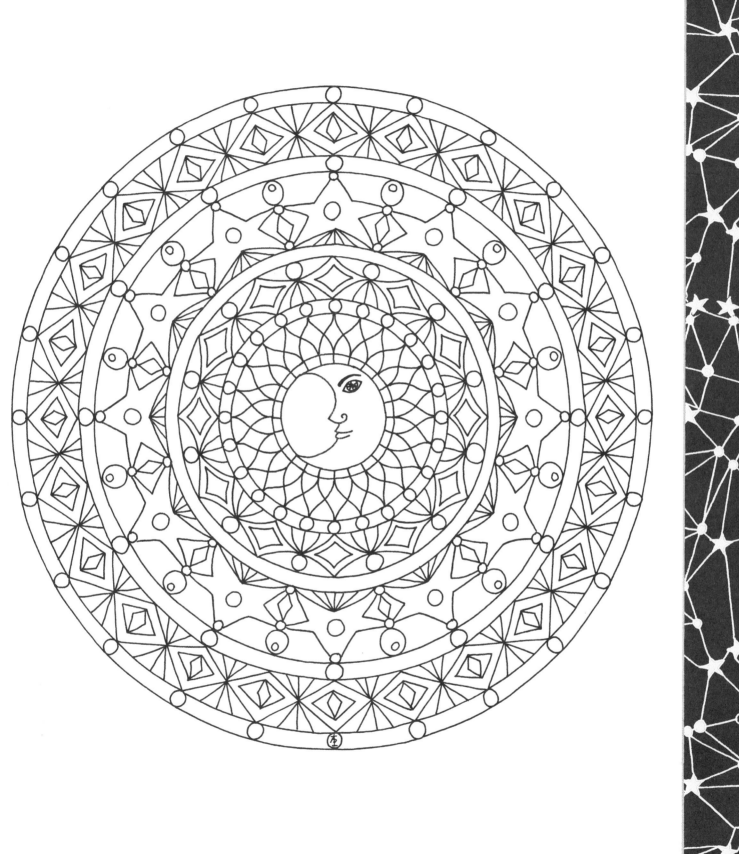

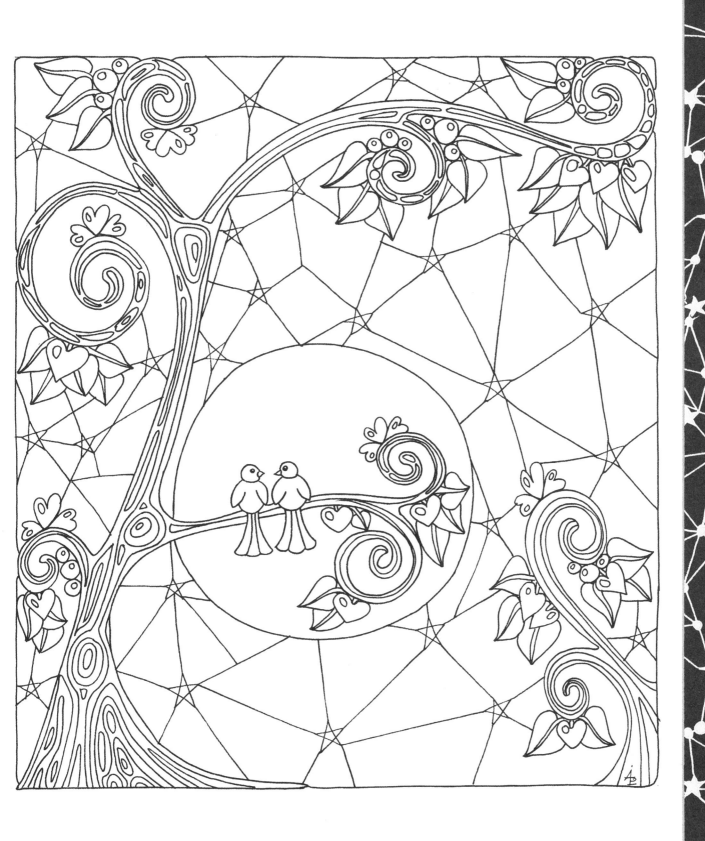

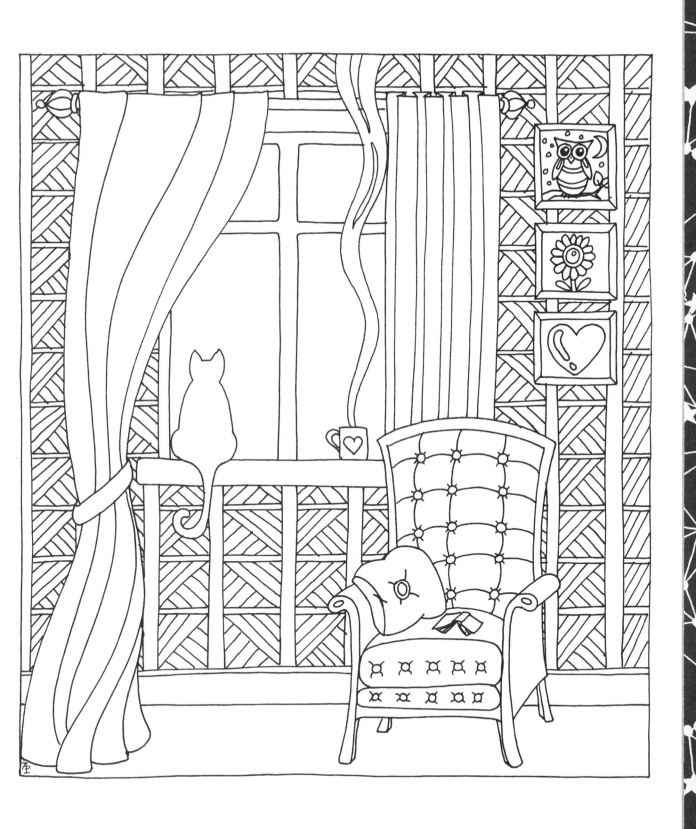

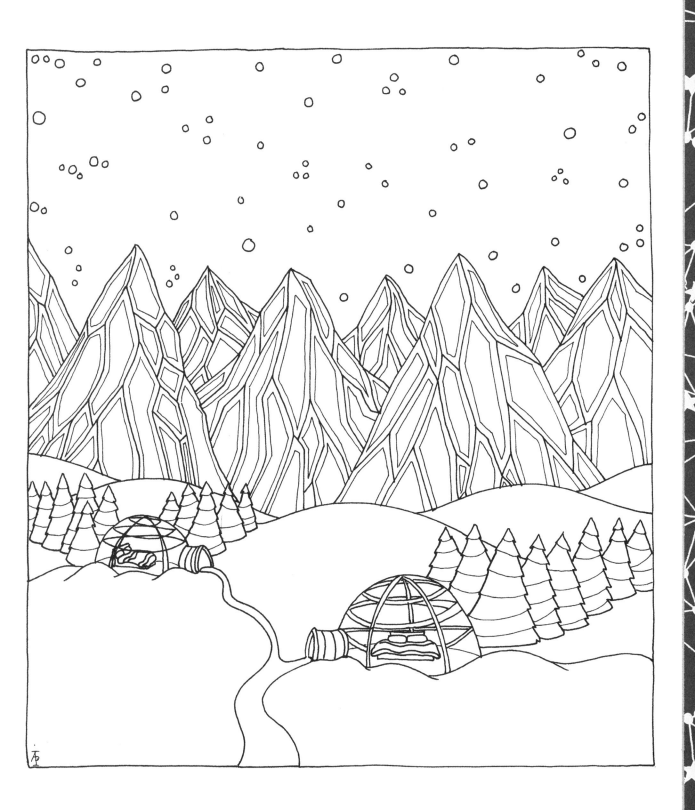

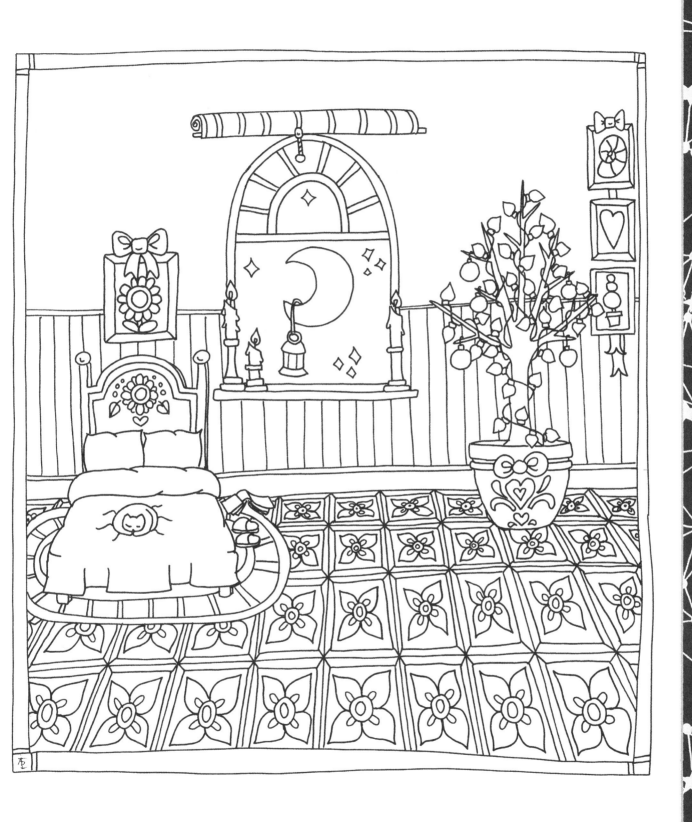

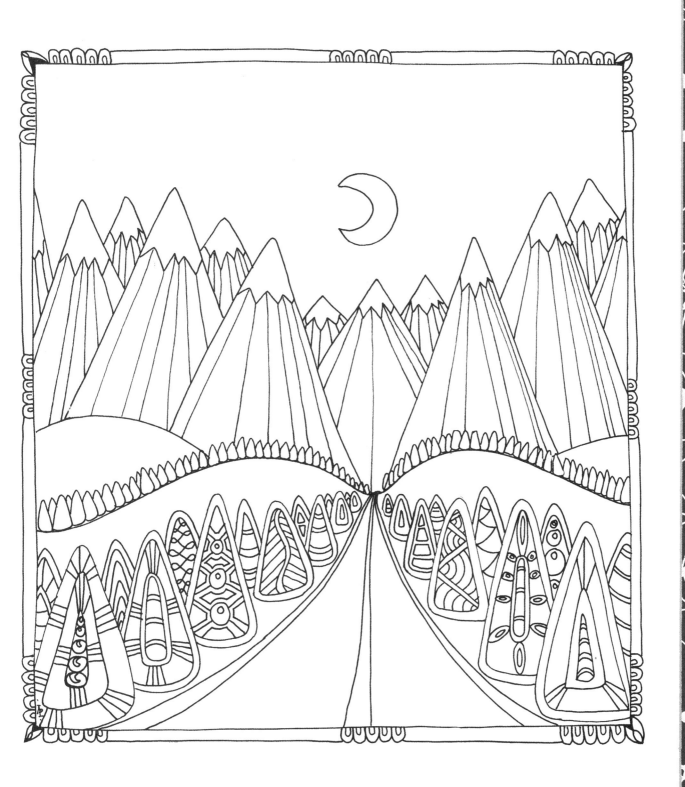

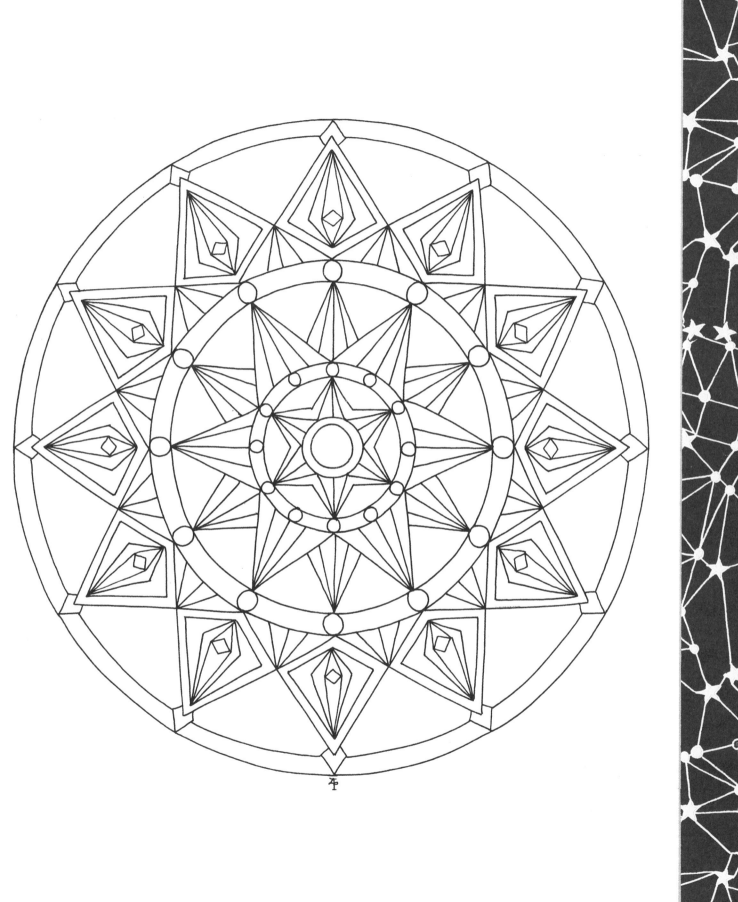

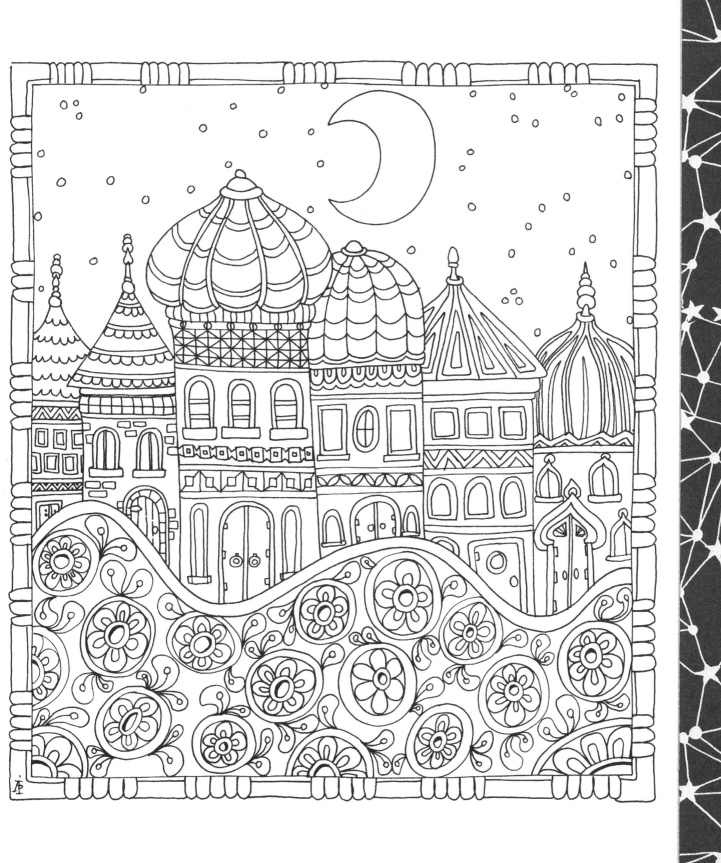

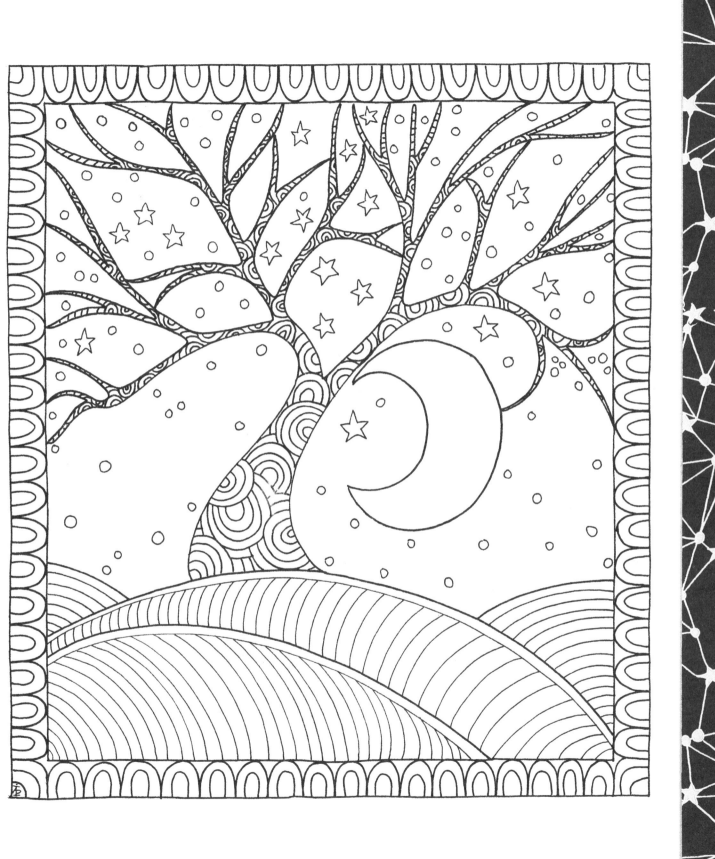

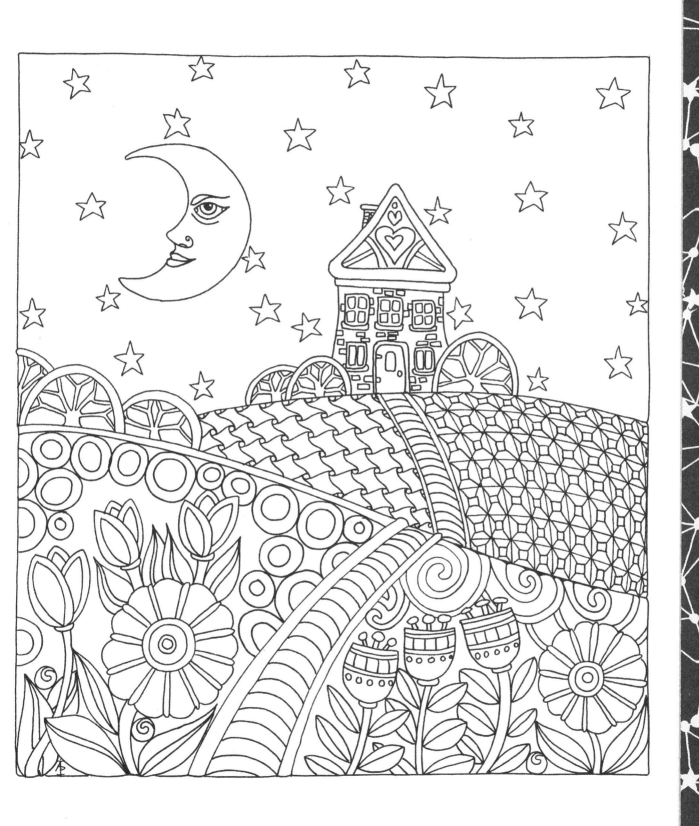

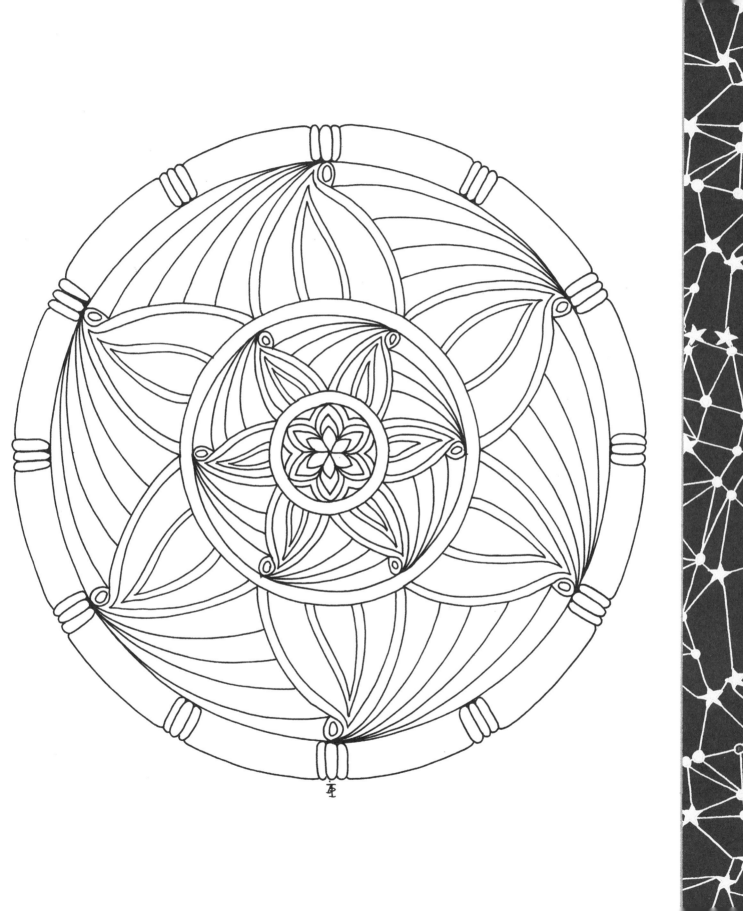

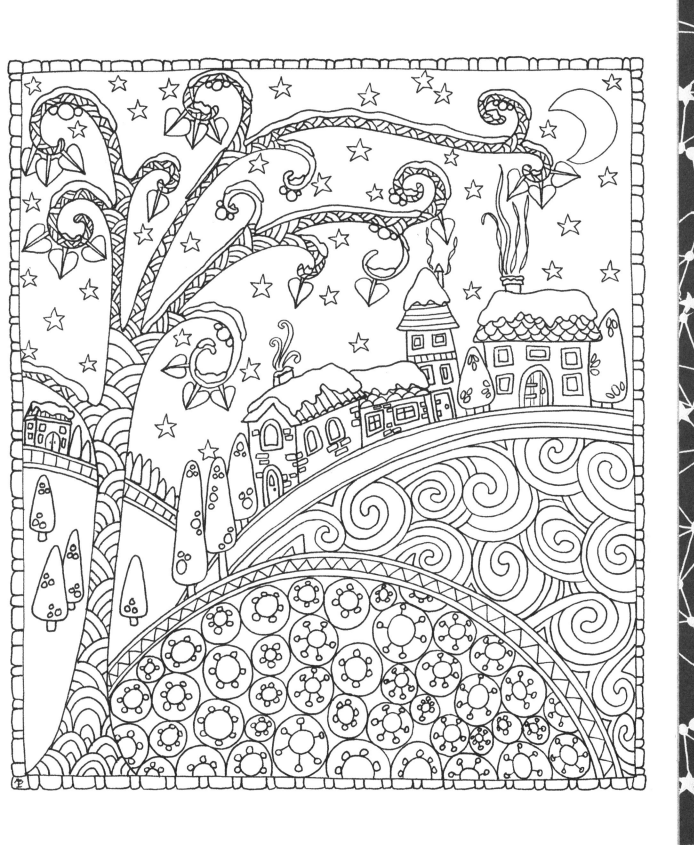

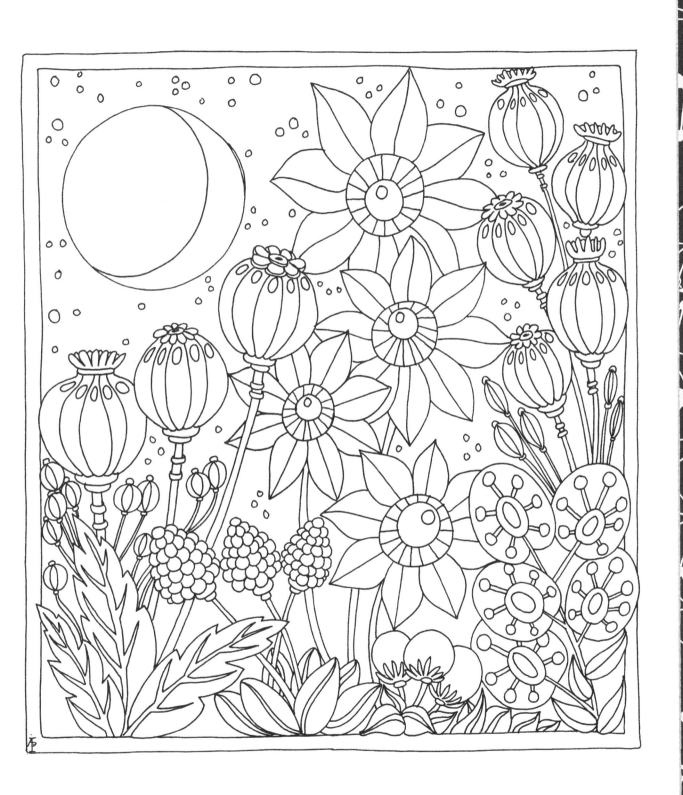

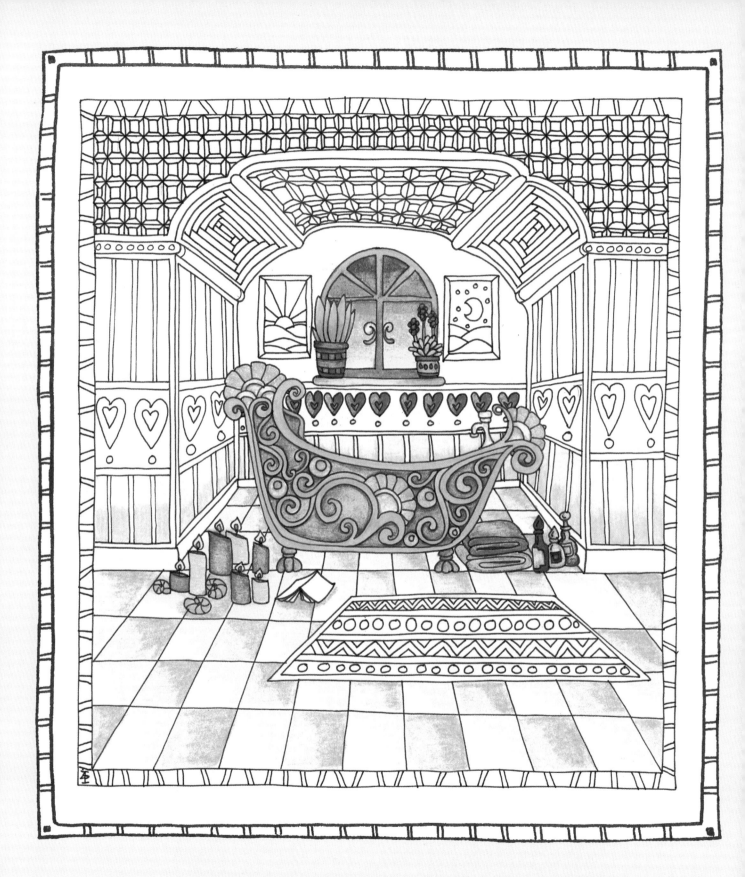

Chapter 2
COZY COMFORTS

Being comfortable is paramount for helping you sleep well. Lying on the right surface, cuddling in the right blanket, and nestling into the right pillows can help one drift off to sleep more easily. Even just cozying up in a chair with a warm beverage by a fireplace in winter or relaxing in an airy, cool room in the summer can provide enough comfort to lull you into a soothing slumber. We all have a sense of what makes us feel cozy and comfortable, which may change with the seasons or in life, as our preferences may shift. When you discover what your "cozy comforts" are, it is important to maintain them in your resting environment for greater sleeping consistency. The following images focus on scenes of coziness, including nook-style beds, woolly socks, candles and fireplaces, warm beverages, stuffed animals, snug blankets and pillows, and cuddly pets. A blank panel is included at the end of the chapter to encourage you to draw and color a cozy comfort that is special to you.

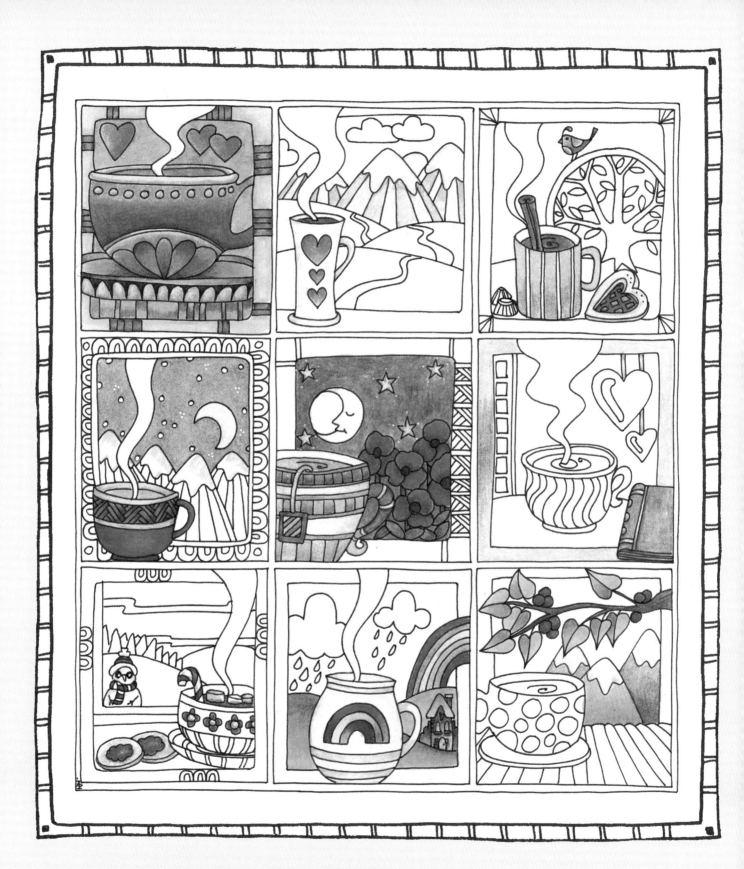

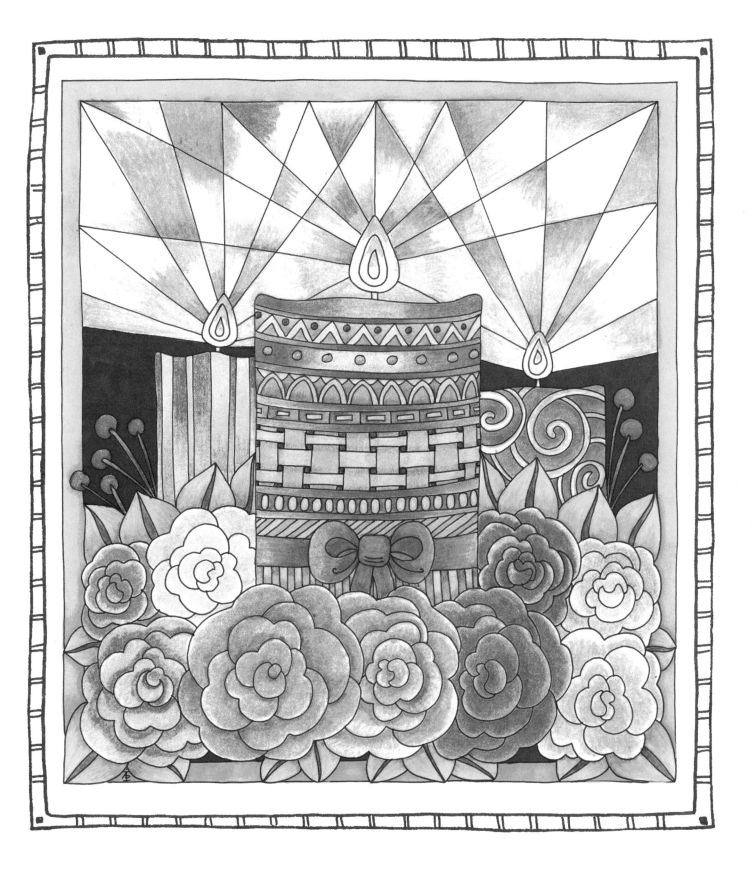

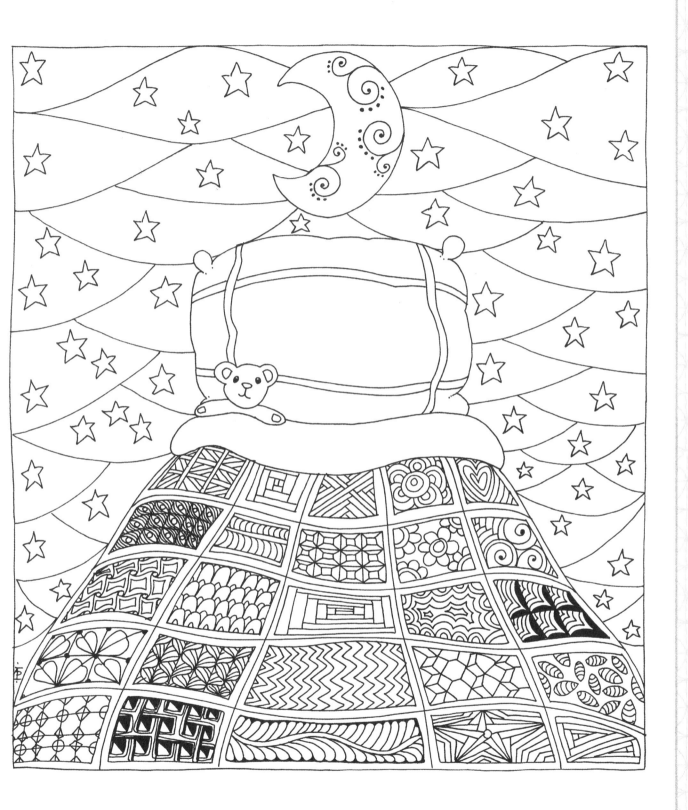

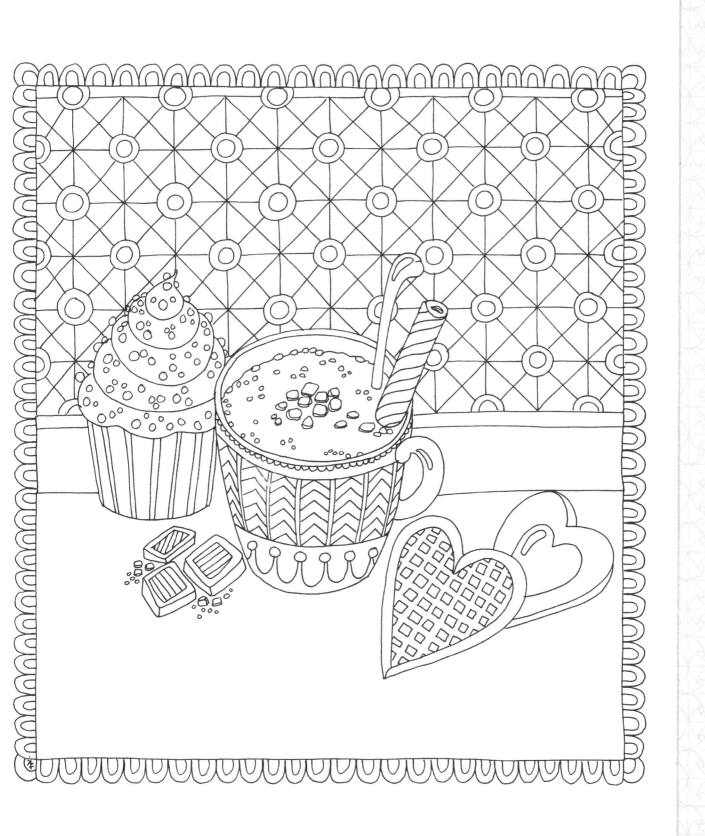

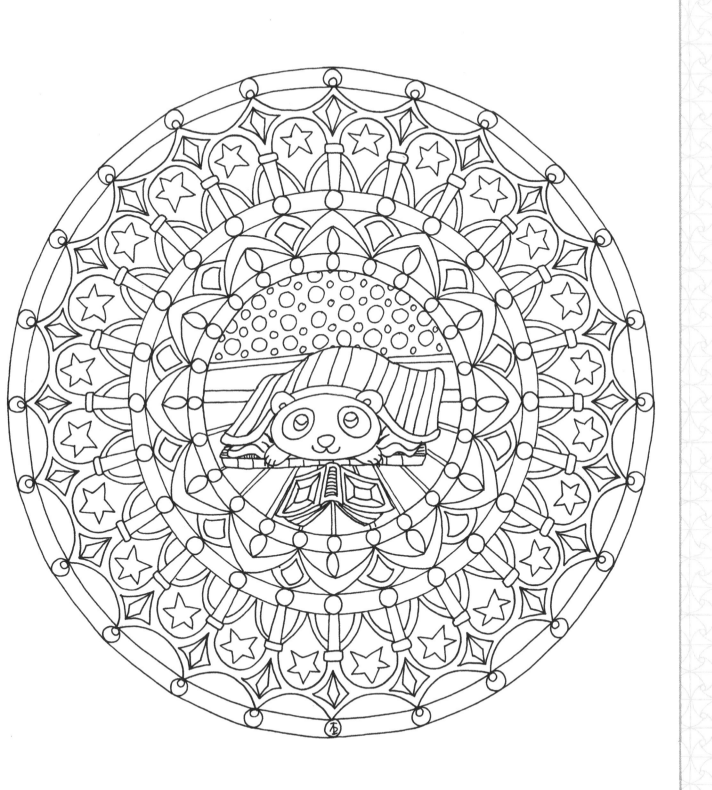

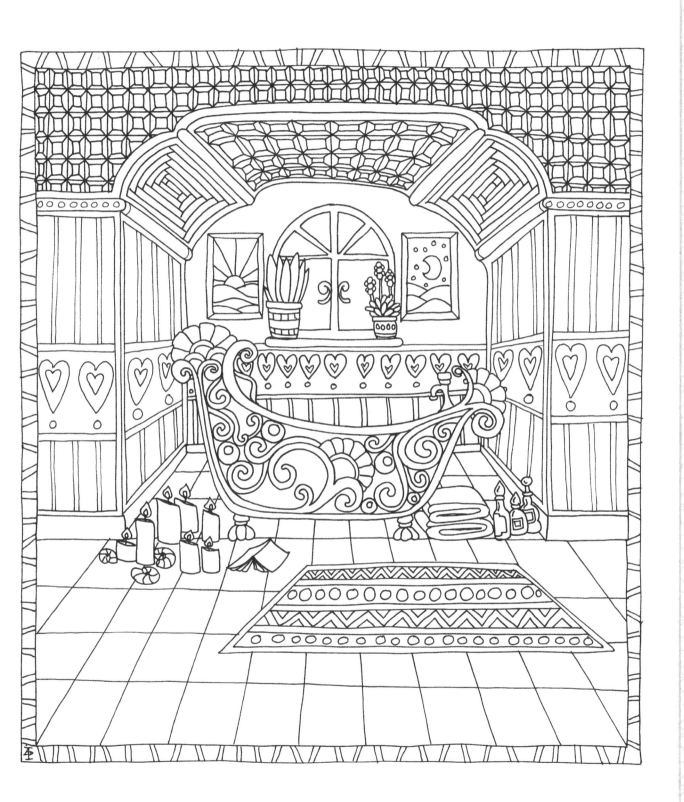

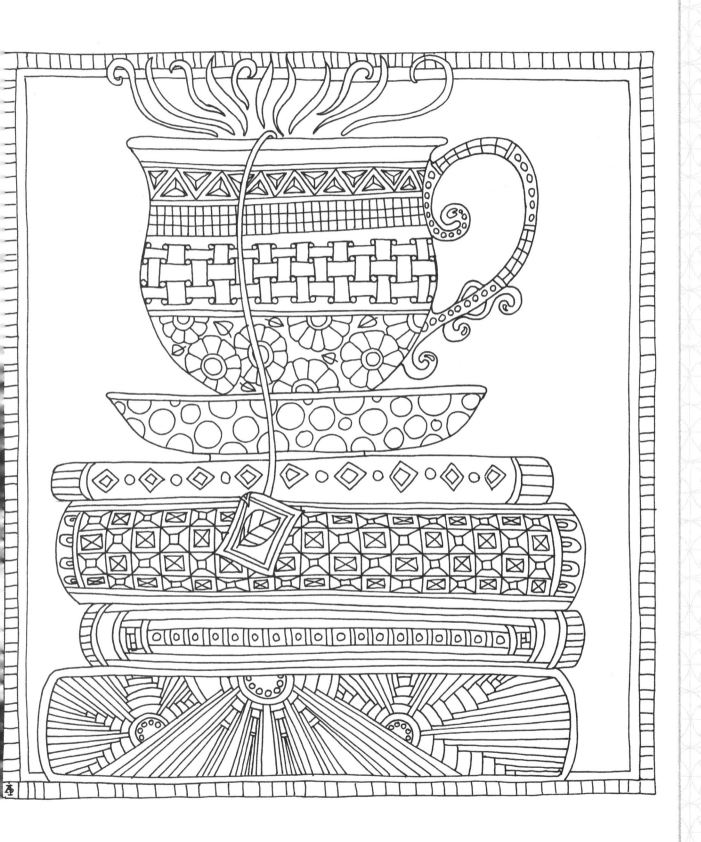

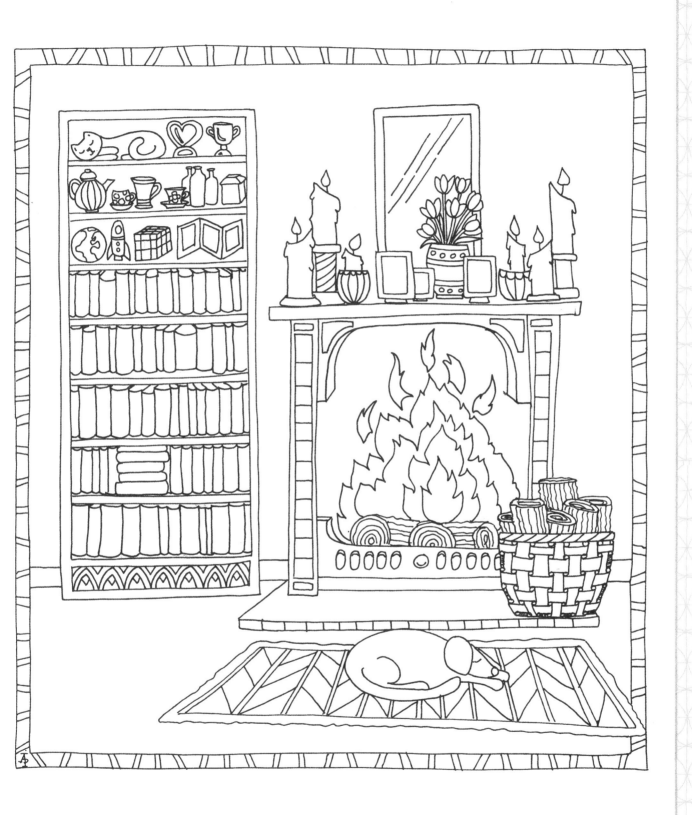

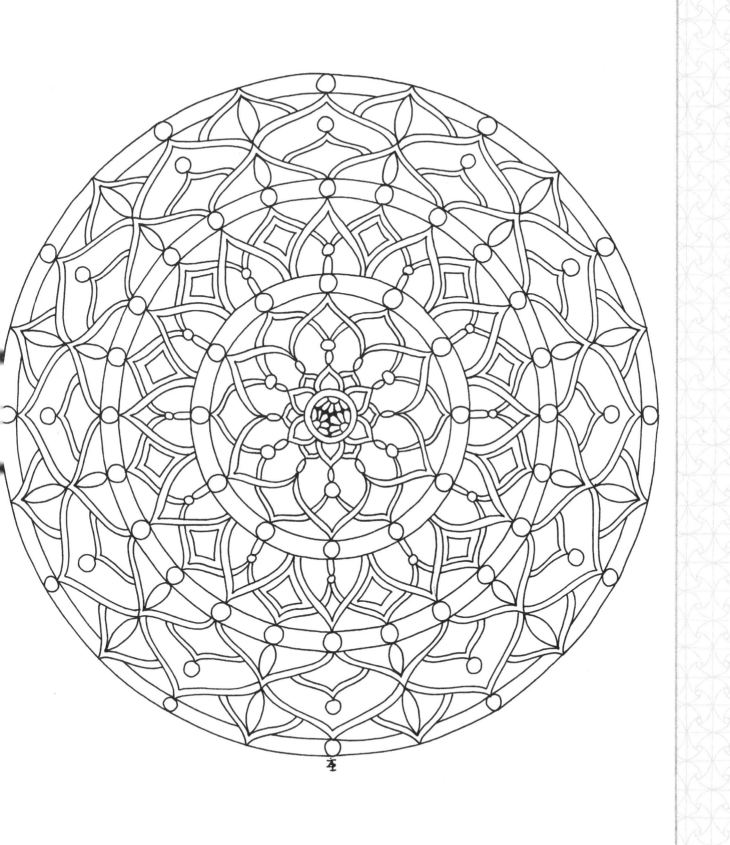

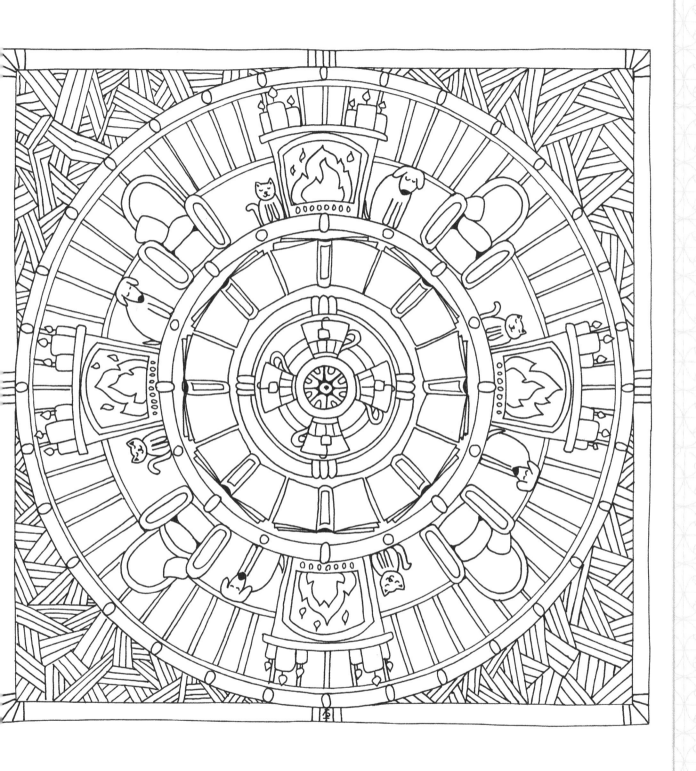

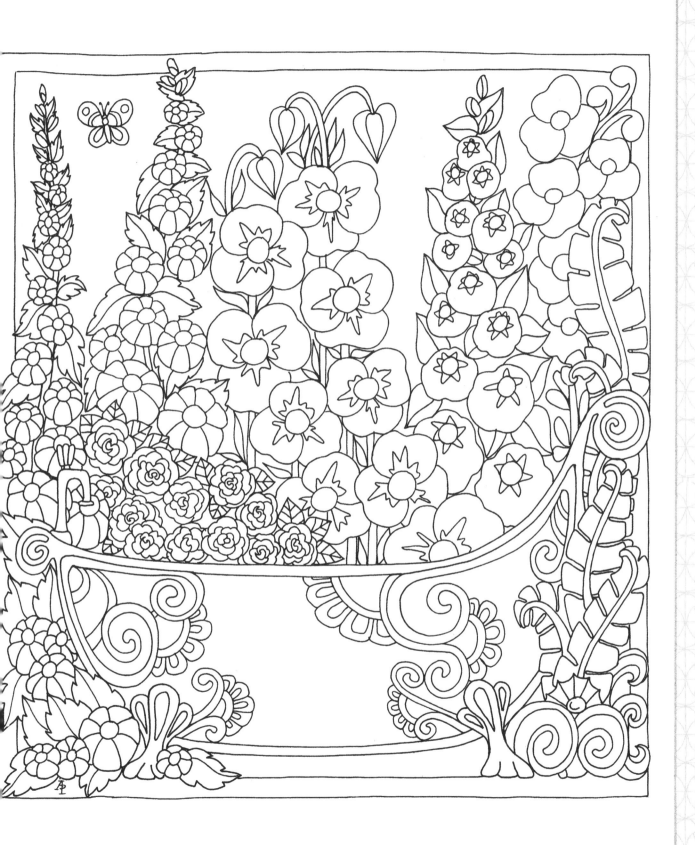

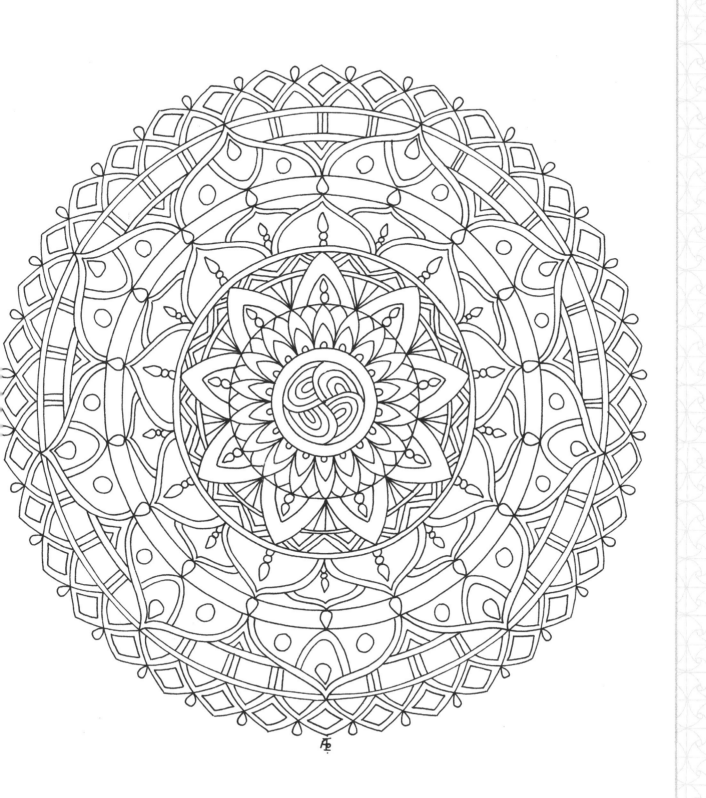

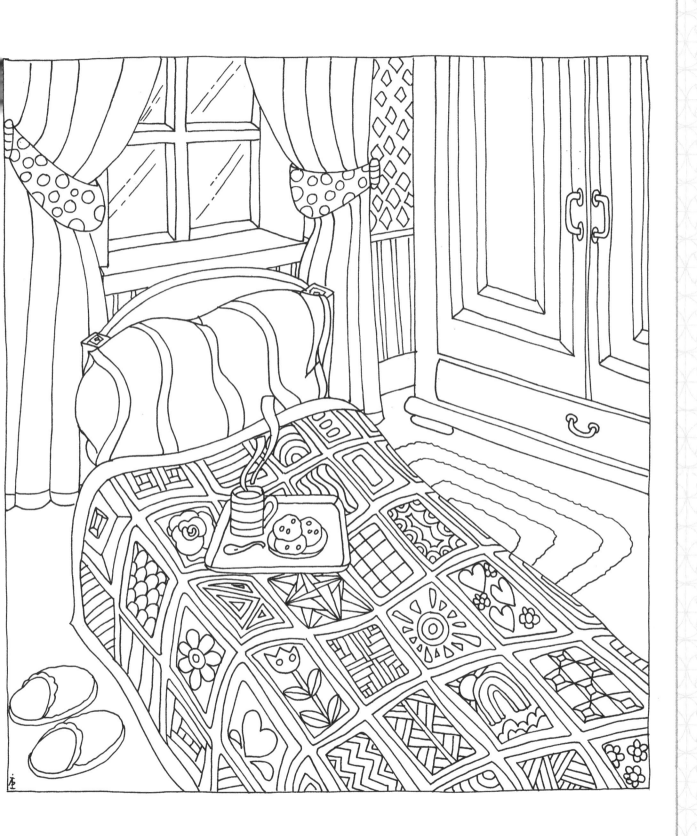

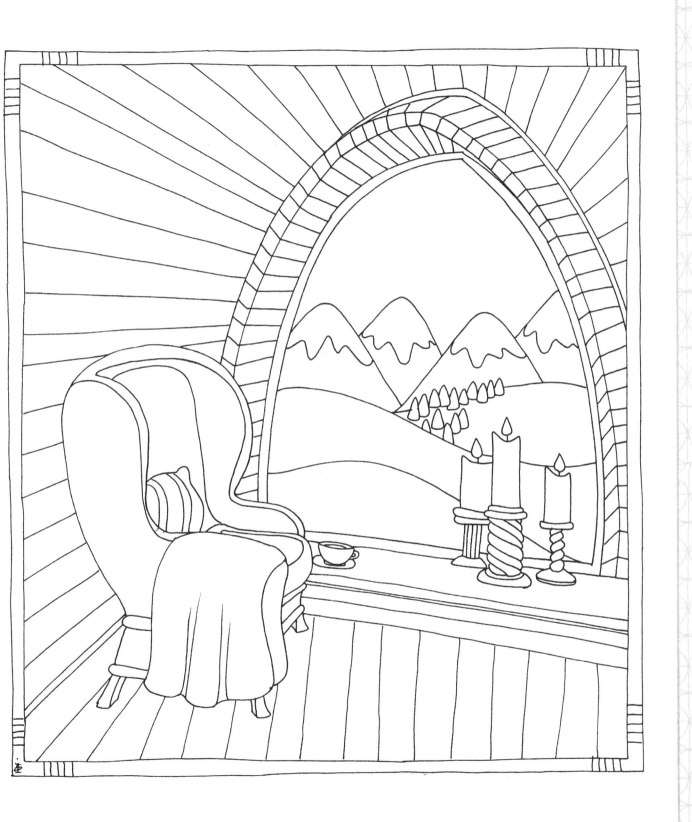

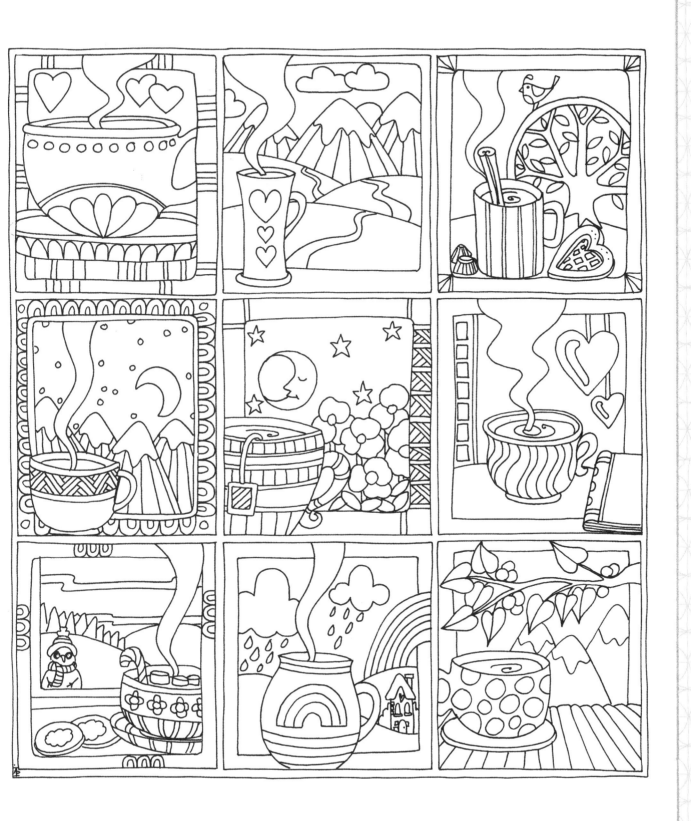

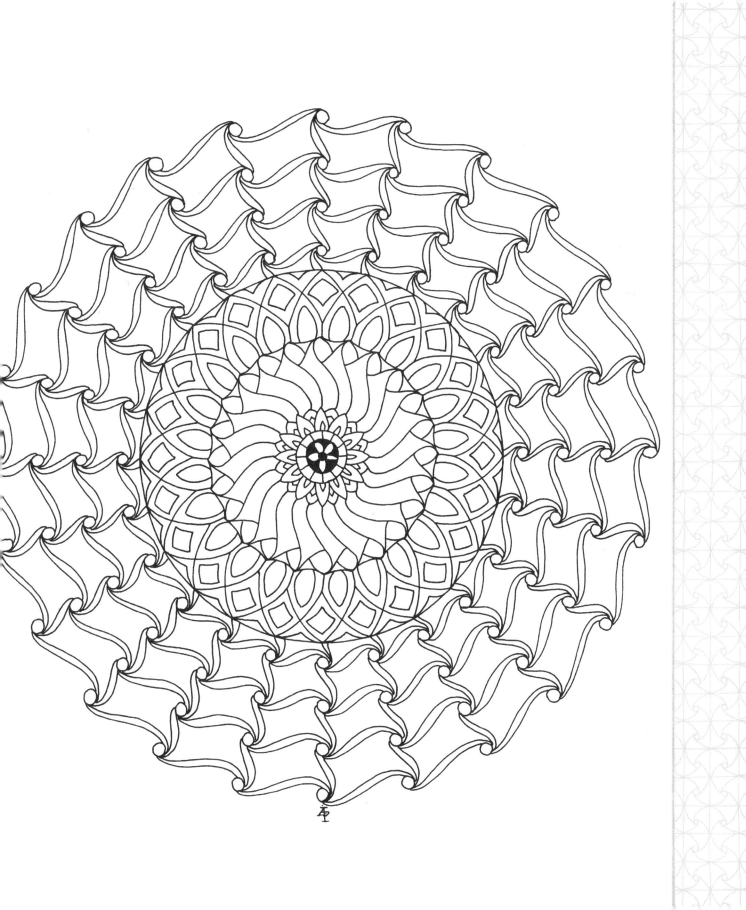

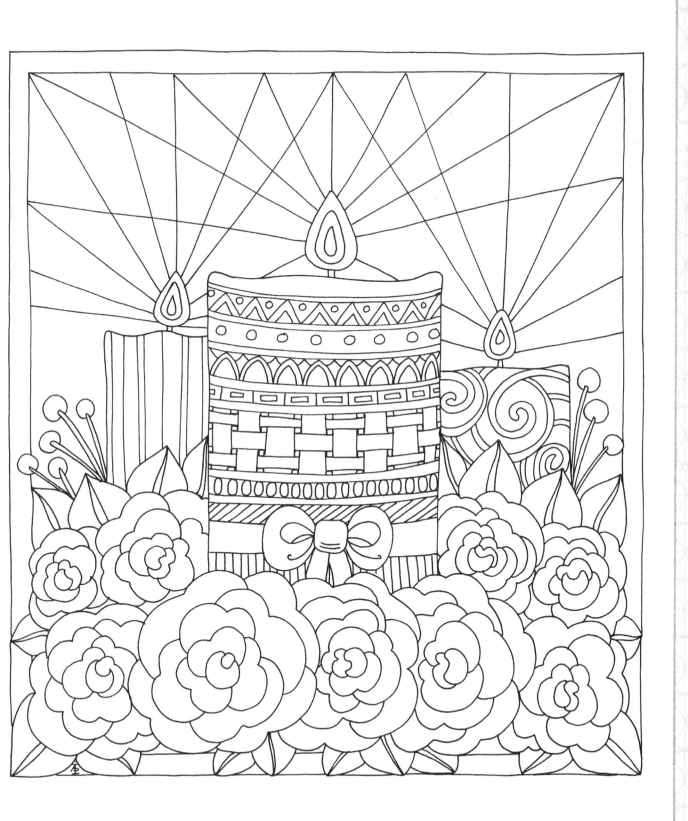

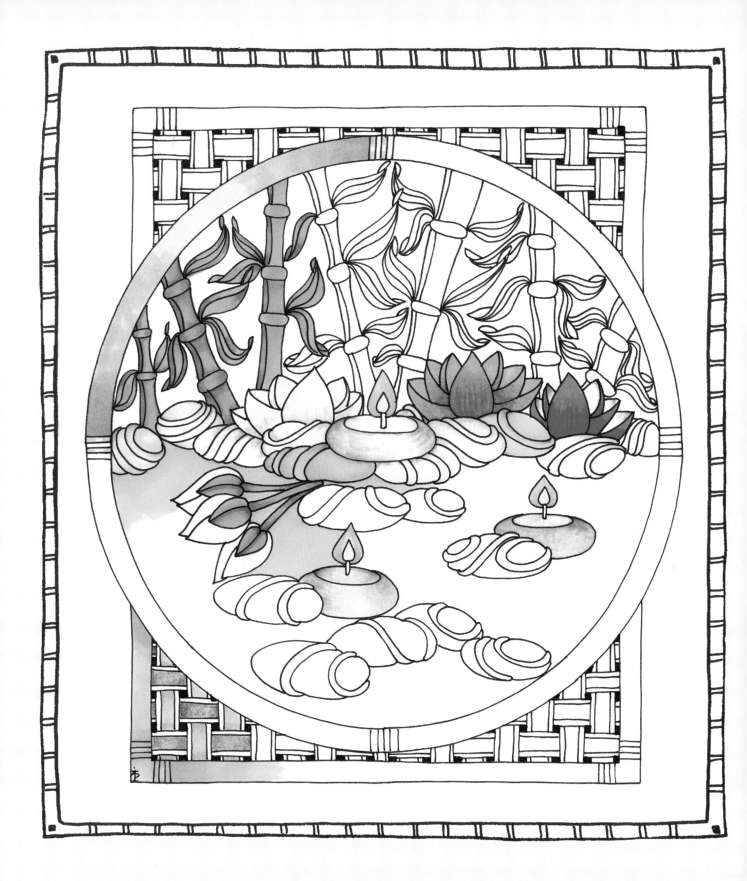

Chapter 3

QUIET GETAWAYS

Sometimes taking a break from the status quo can help us recharge and reset our circadian rhythms. Getting away to a retreat center, cabin, spa, or beach, away from your everyday life, can promote more restful sleep. Making time for such respites can help you maintain a more relaxed state, as well as rejuvenate you, for improved sleep. If you are tight on time and money, you can create a quiet getaway in your own home by finding a spot that is restful—it could be your bedroom, a balcony or deck, or a special relaxation room that you set up for rest or meditation. Even if you can't get to your desired location physically, you can visualize images that mentally and emotionally help you to relax and thus sleep better in your everyday life. The following images focus on different types of getaways, including quiet cabins, lush gardens, secluded beaches, exotic spas, peaceful lakes, and mountain retreats. A blank panel is included at the end of the chapter to encourage you to draw and color your favorite quiet getaway.

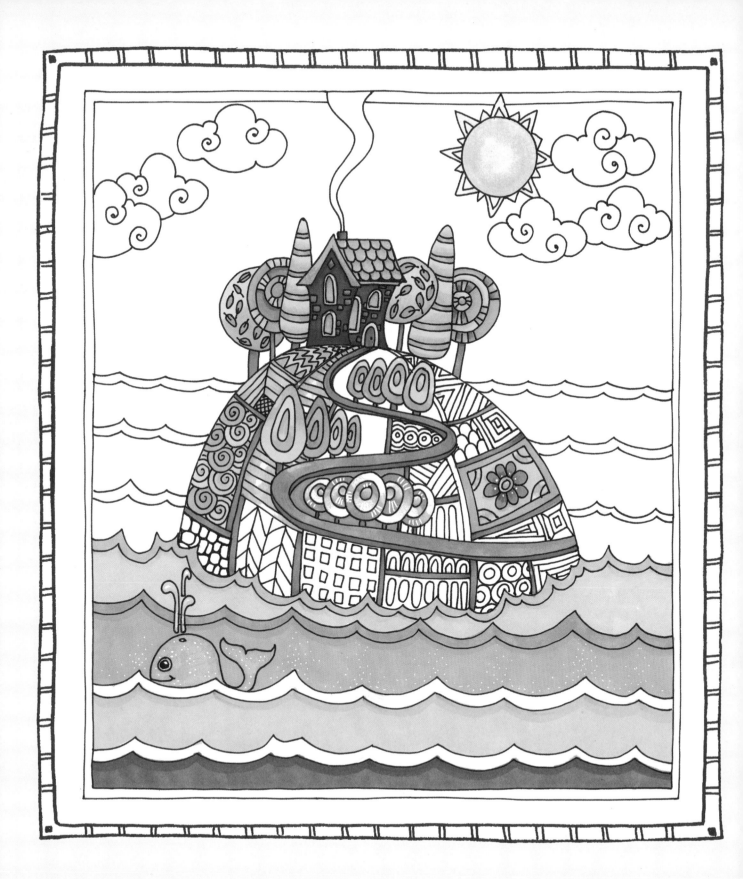

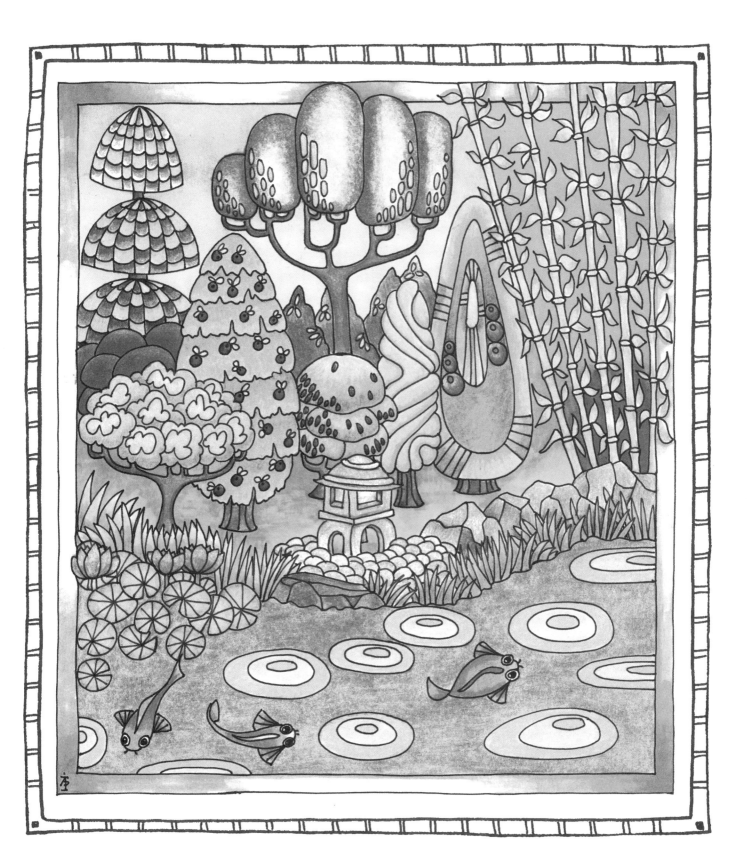

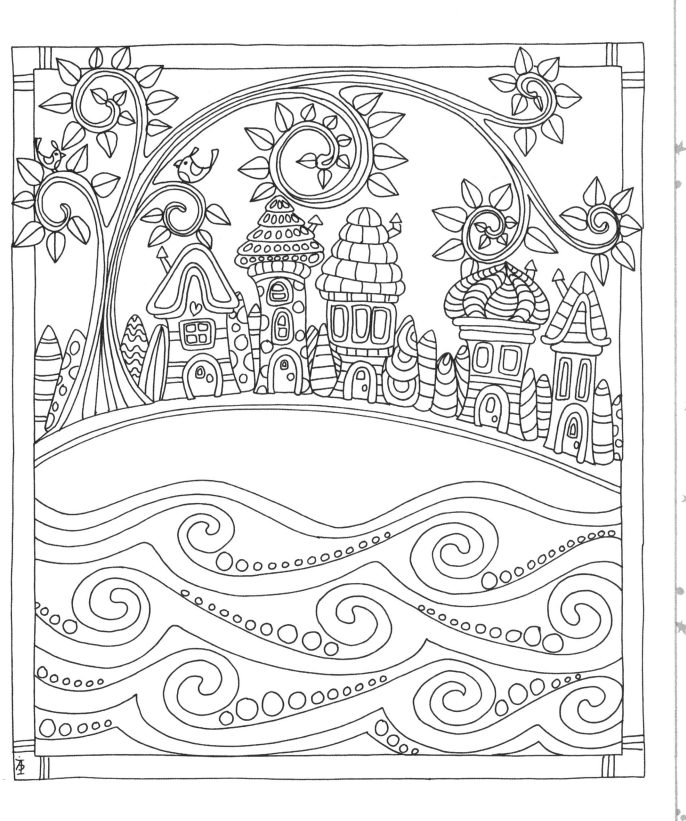

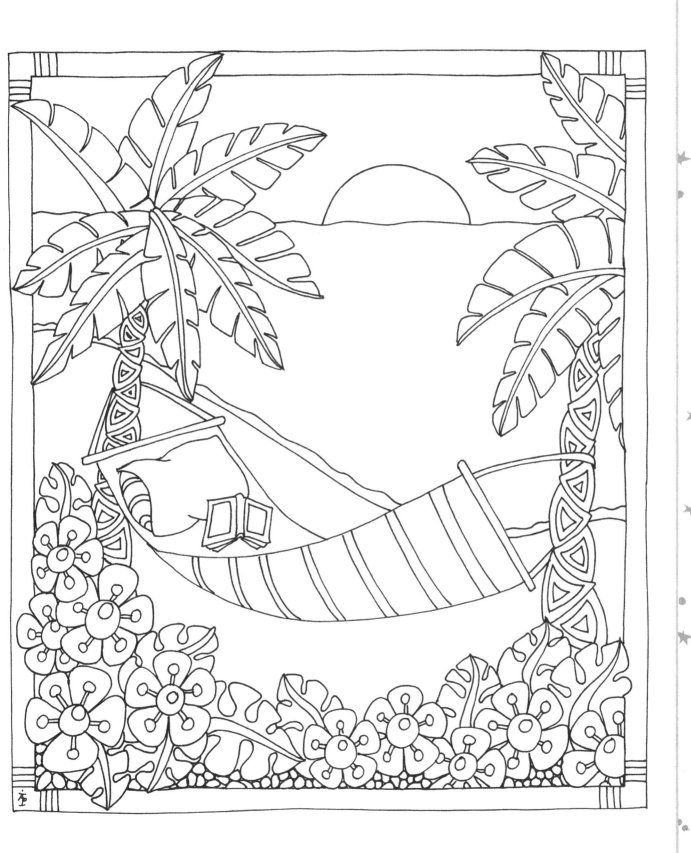

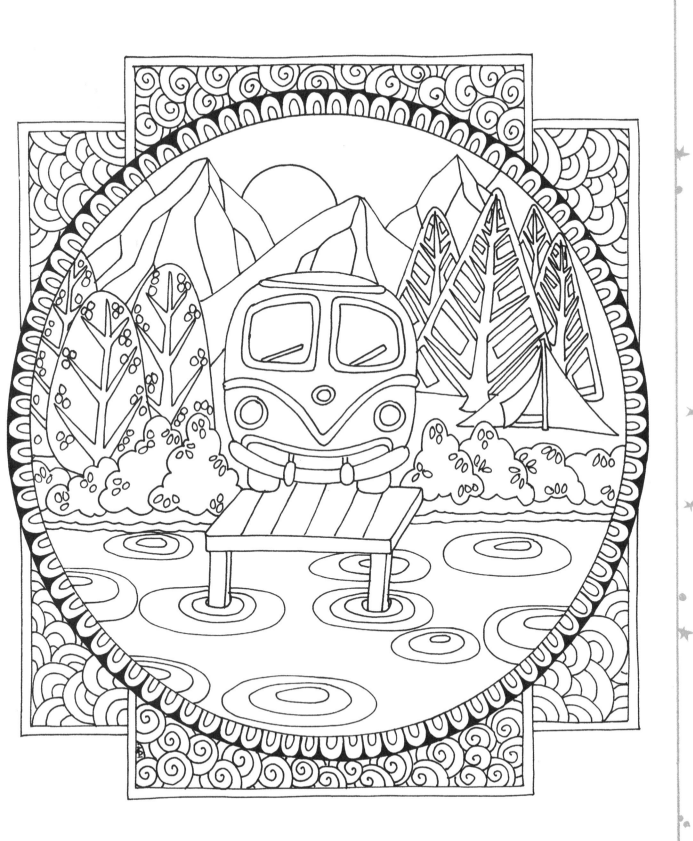

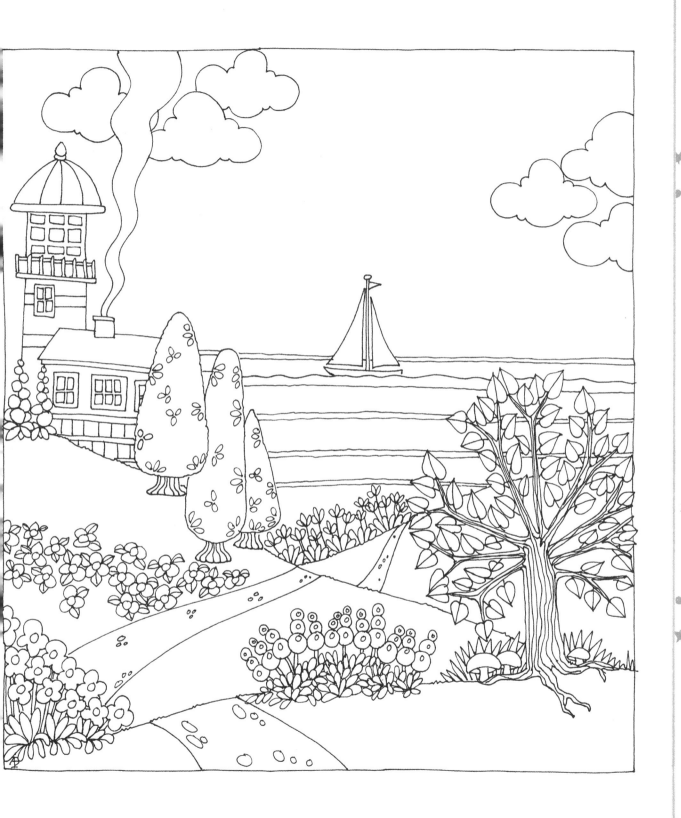

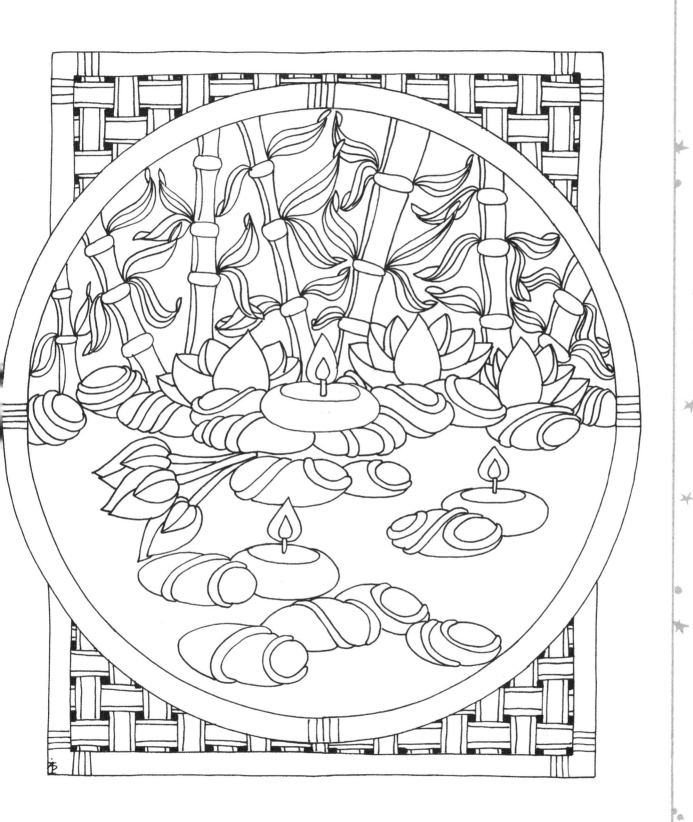

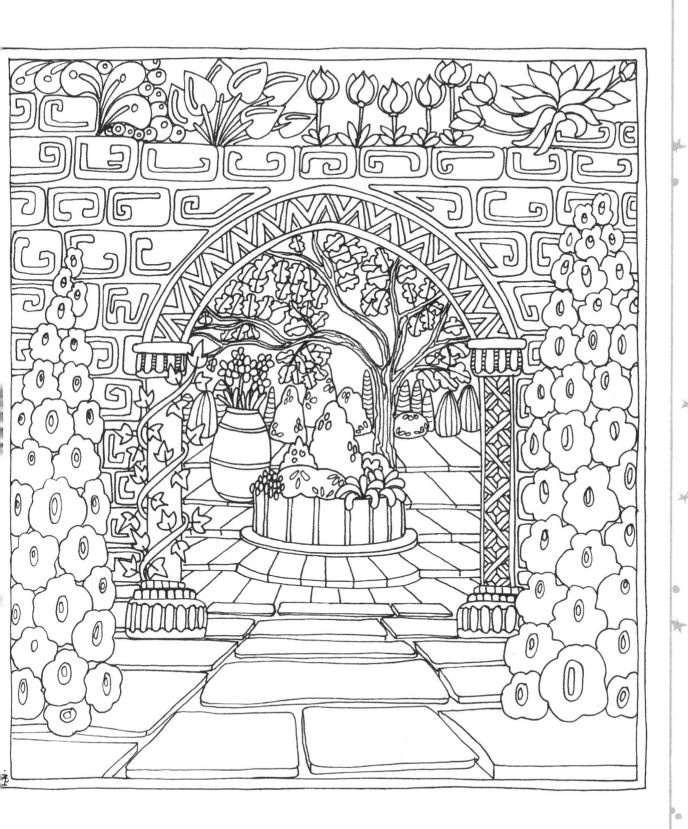

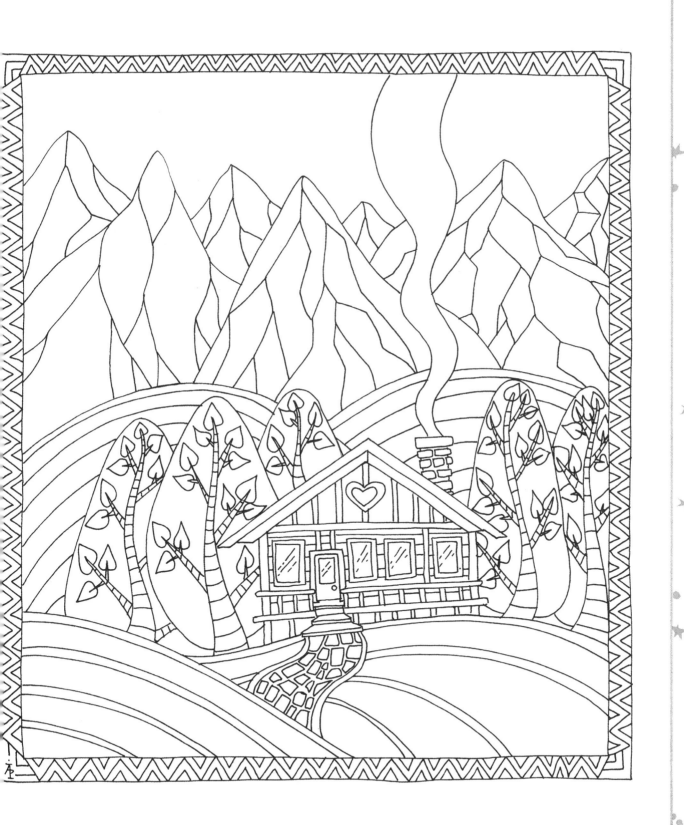

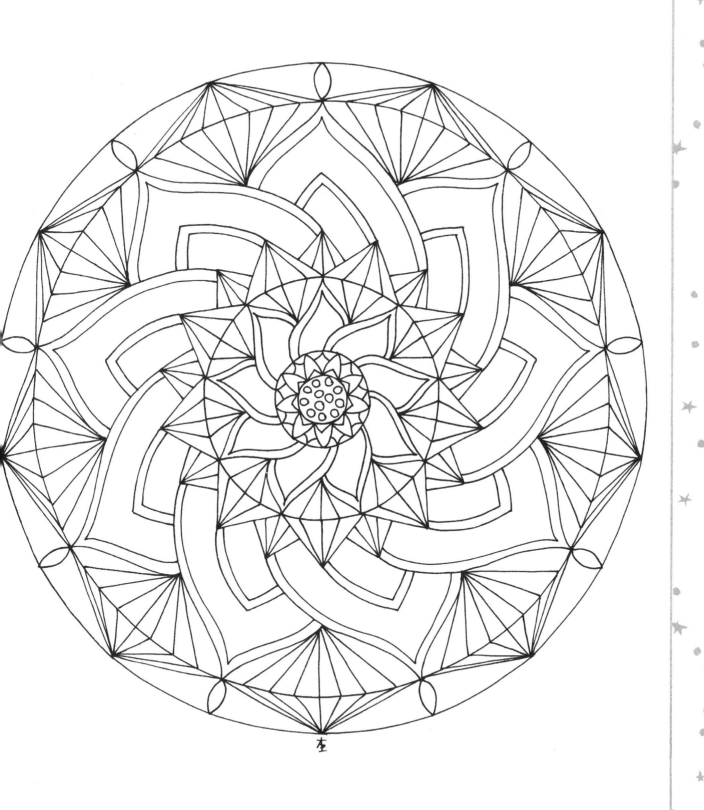

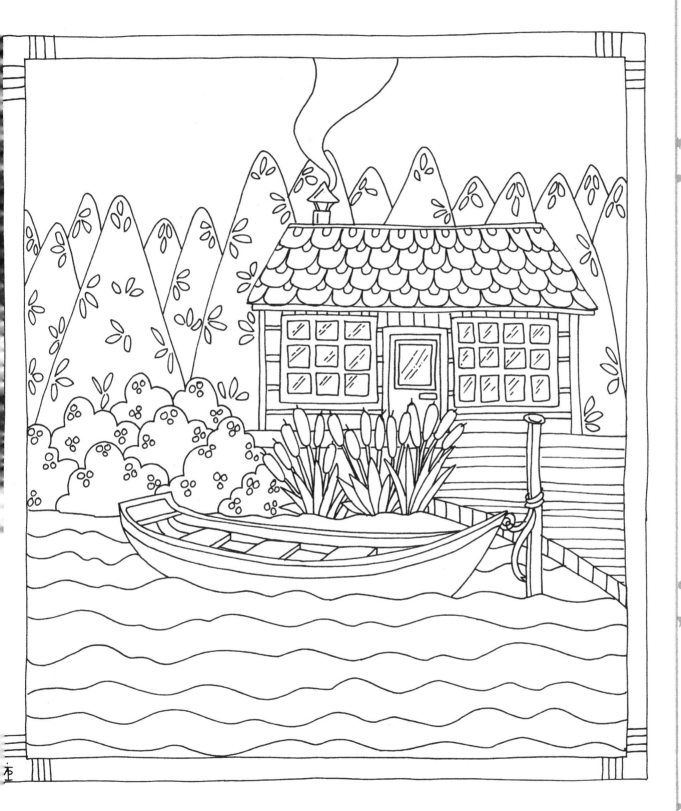

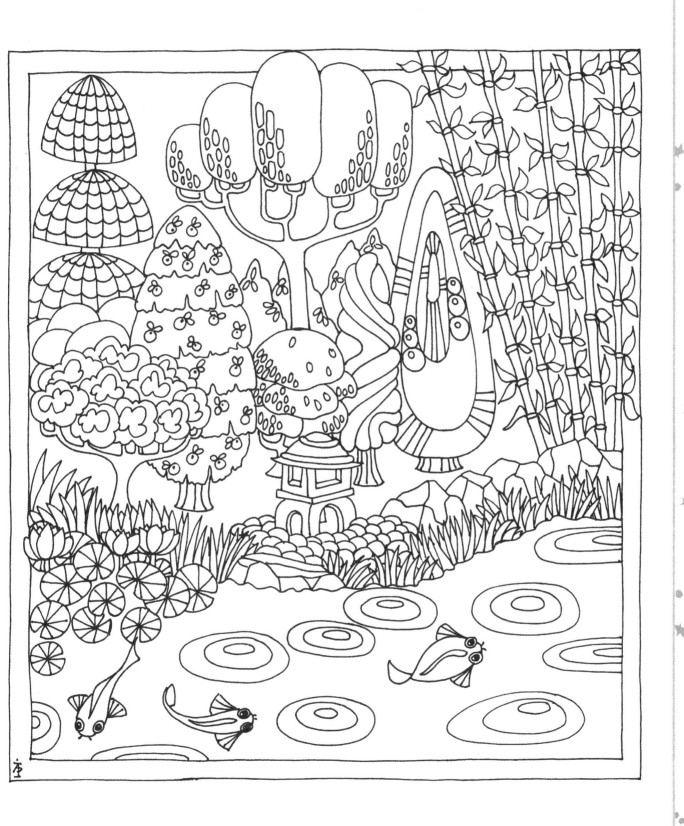

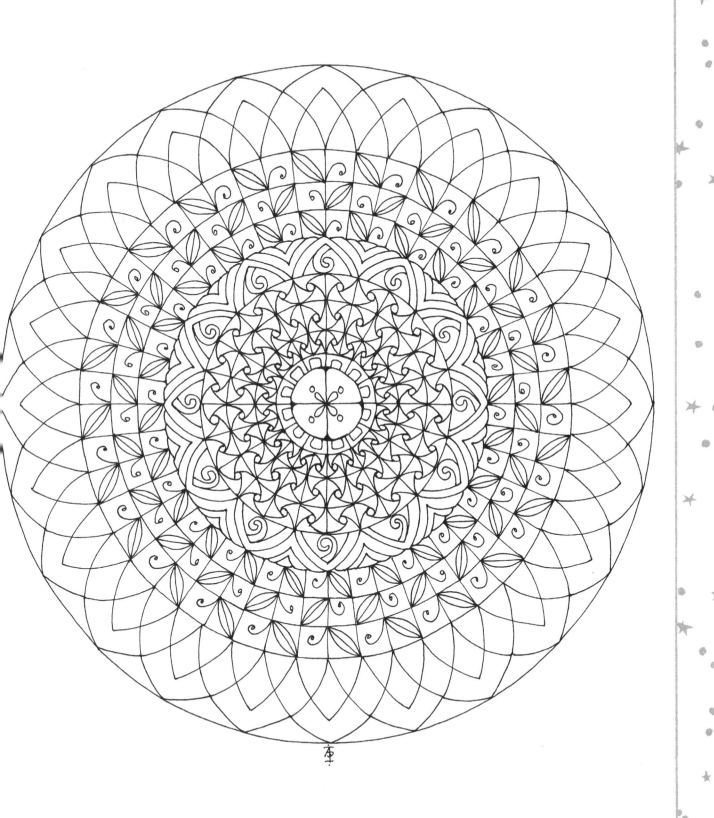

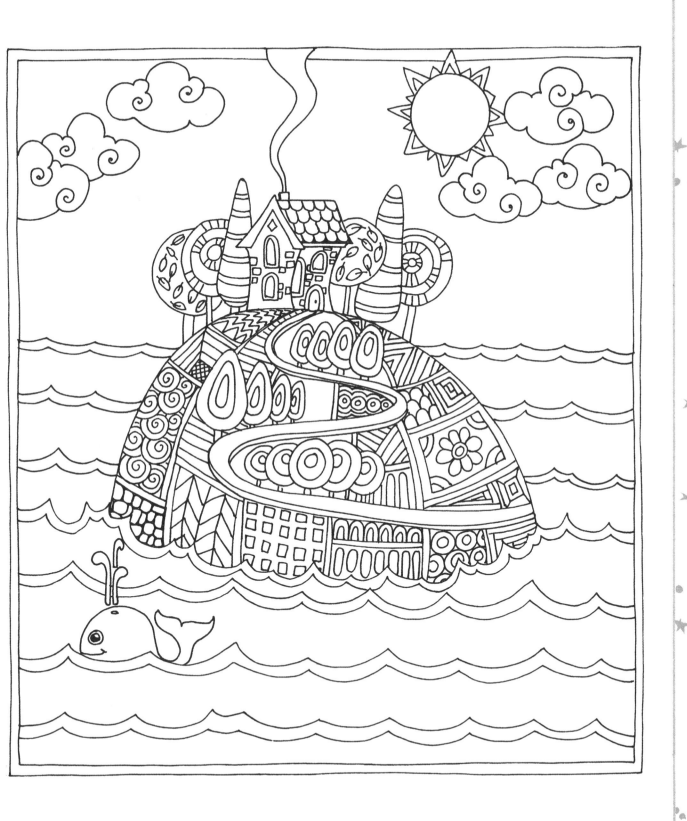

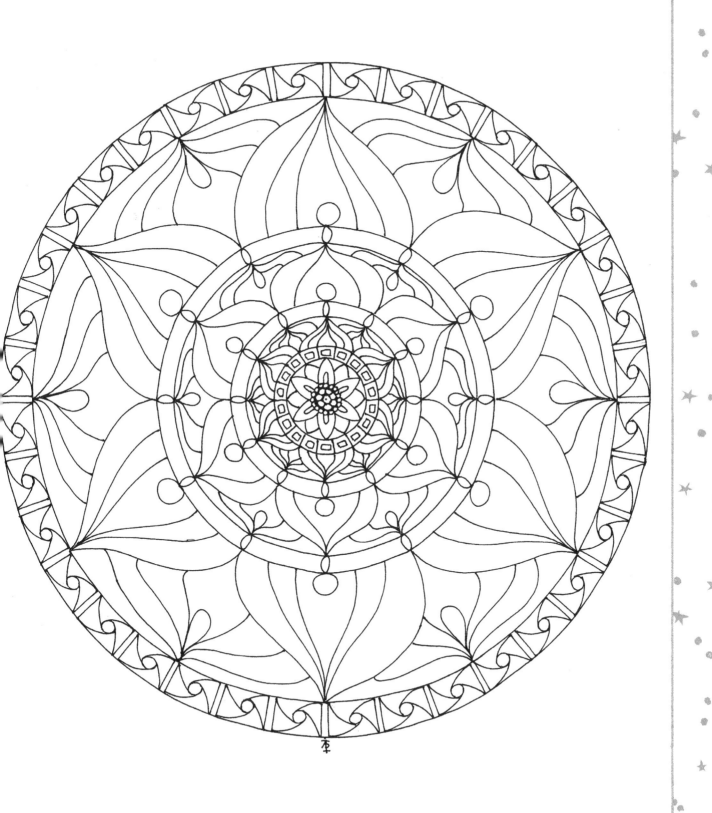

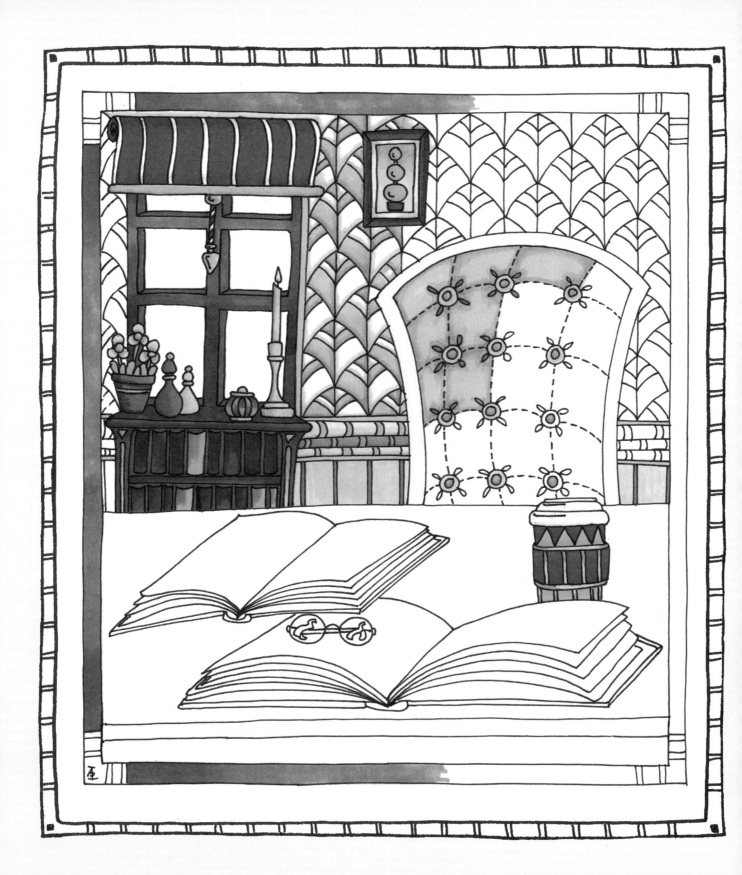

Chapter 4

RELAXING
ROUTINES

A good sleep habit is invaluable, so establishing and practicing a consistent bedtime routine can allow our bodies to get into regular circadian rhythms that help contribute to restful sleep. Doing basic things such as getting organized for the next day, dialing back on the use of electronics a half hour before going to sleep, and having a set bedtime can help contribute to better sleep. You can also do other relaxing things, like listening to soothing music or white noise (rain, ocean waves, binaural beats), taking evening baths, reading a book, contemplating a meditation or prayer, or even coloring or journaling. The following images reflect relaxation, including taking baths, coloring and journaling, drinking tea or warm milk, reading, lighting a candle for meditation or prayer, and envisioning delta brain waves (deep sleep). A blank panel is included at the end of the chapter to encourage you to draw and color your preferred relaxing bedtime activity.

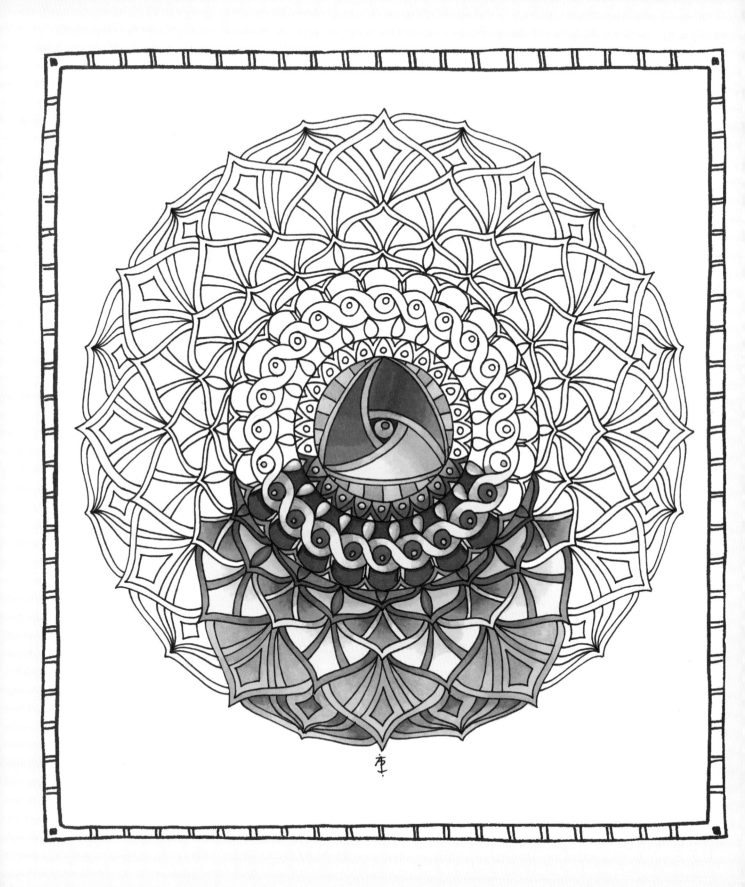

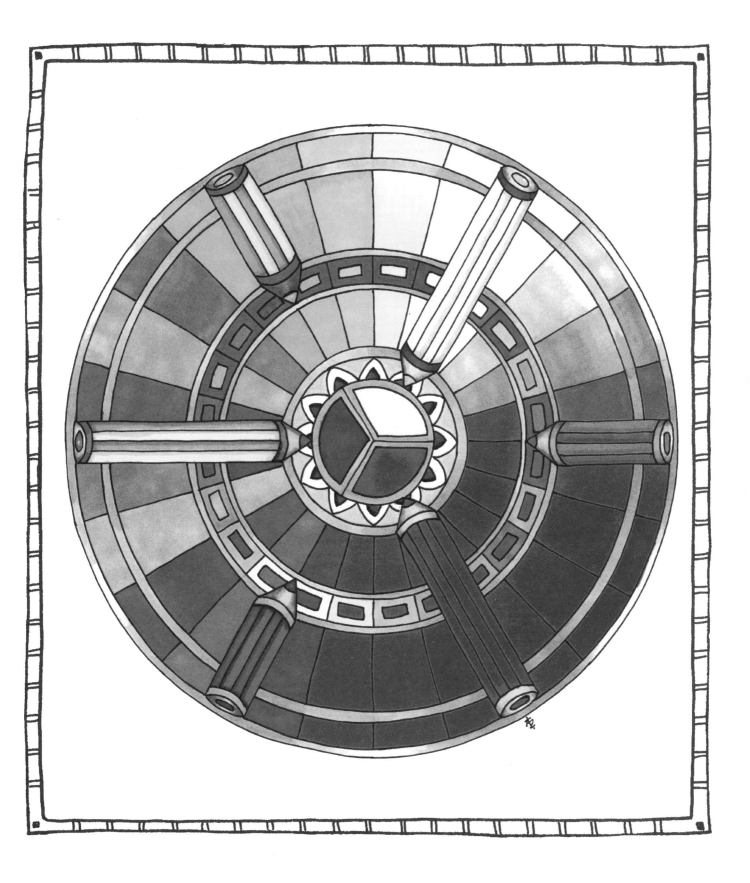

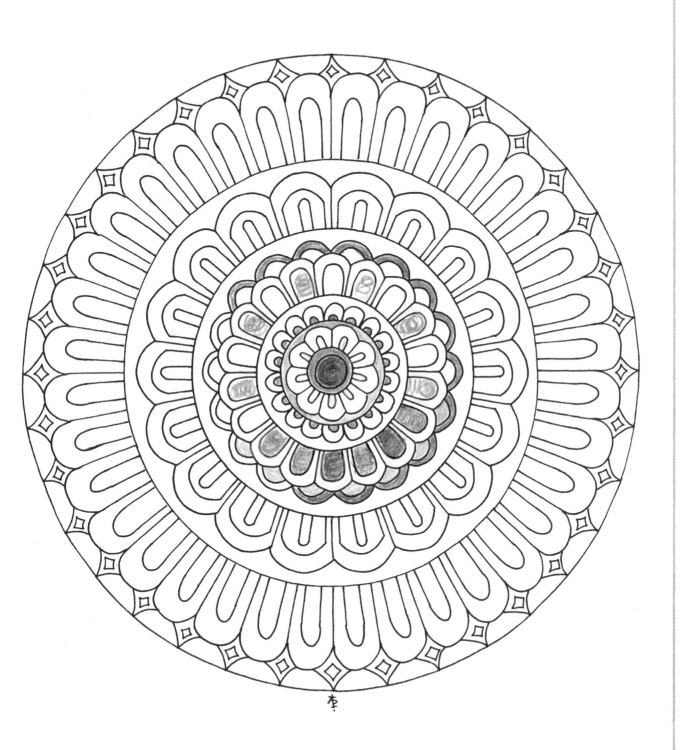

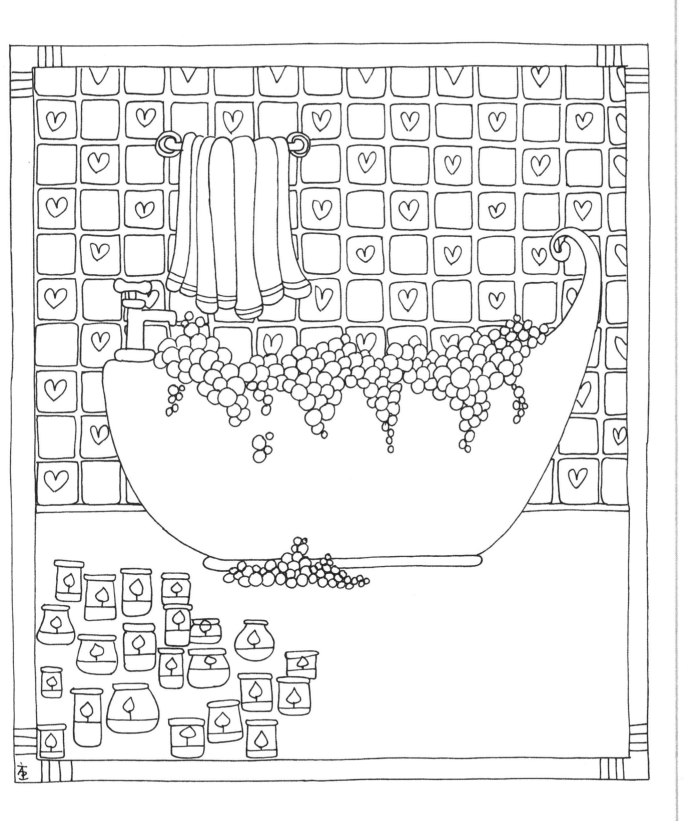

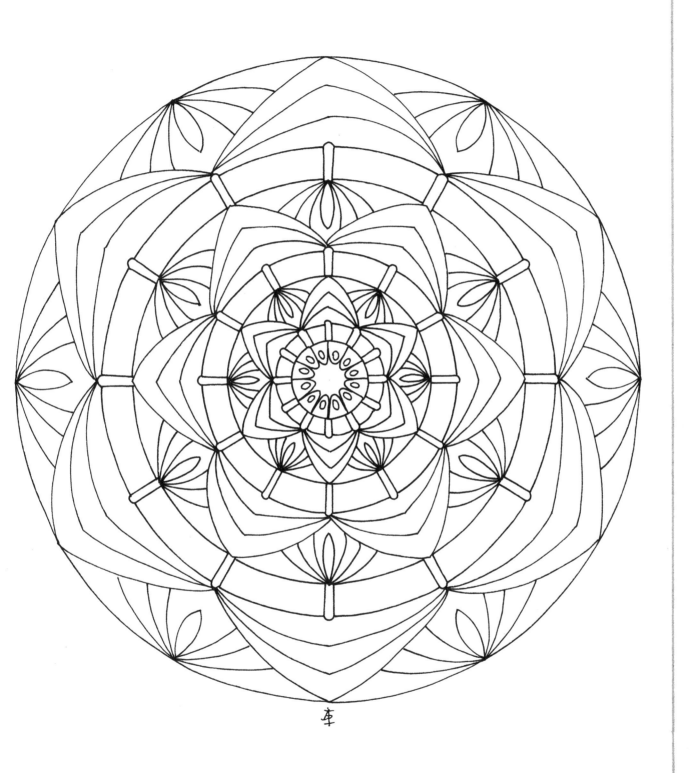

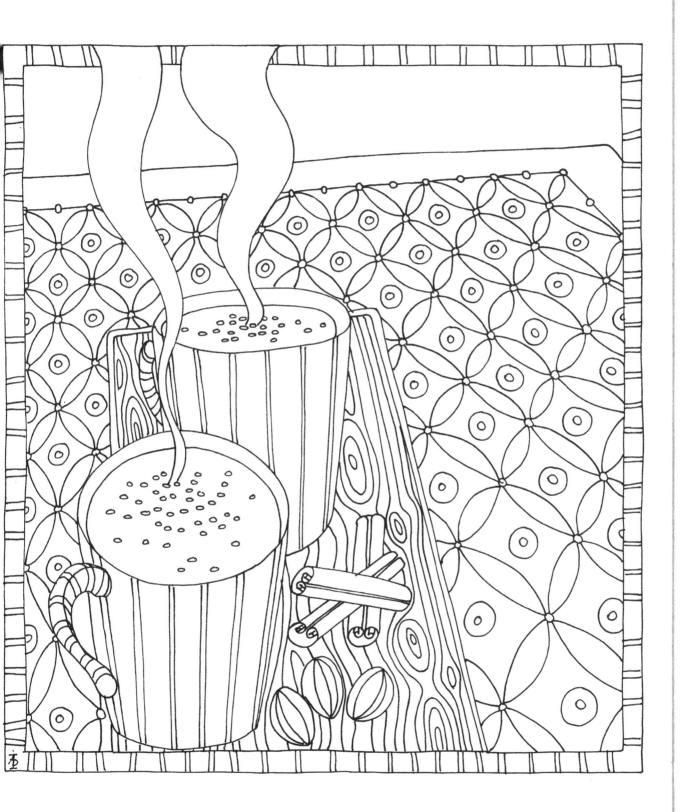

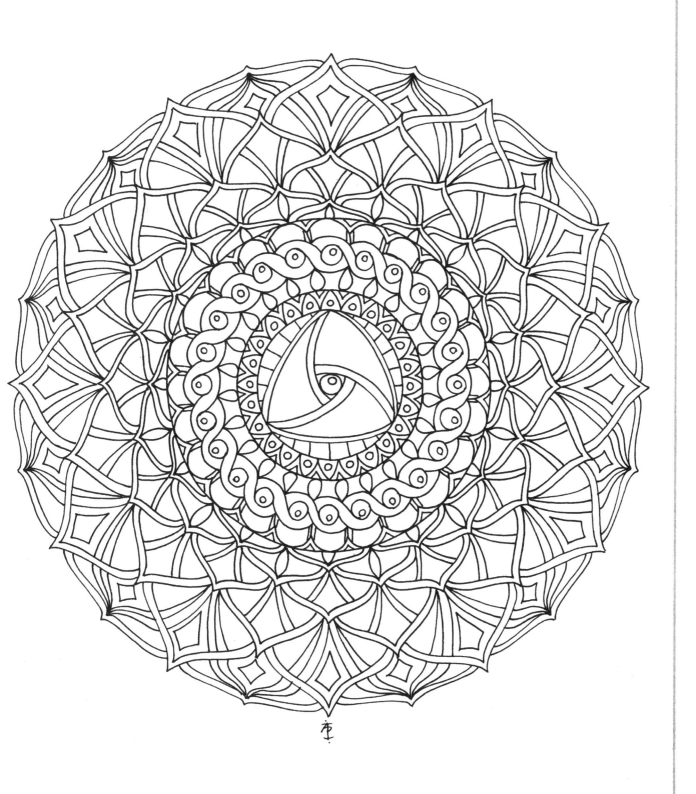

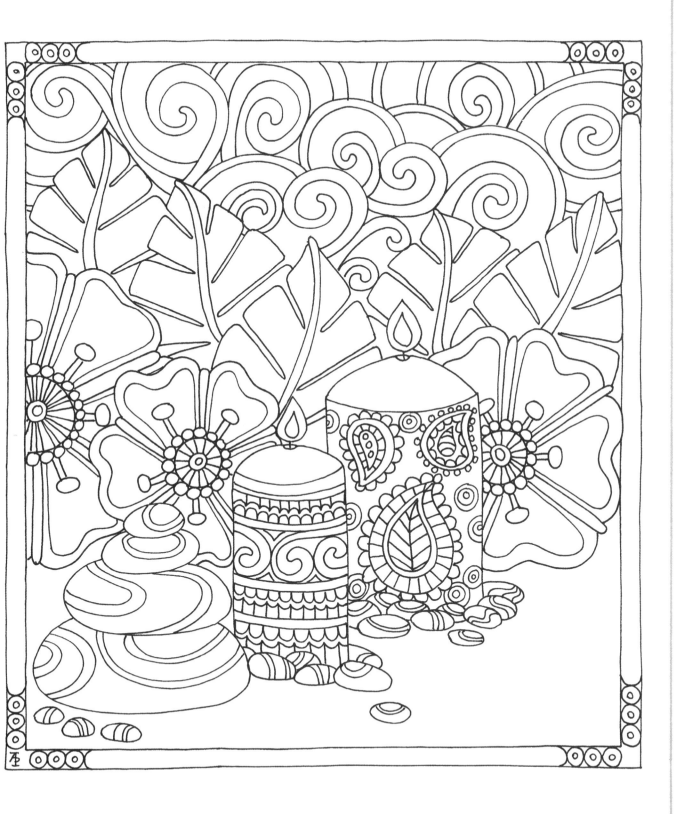

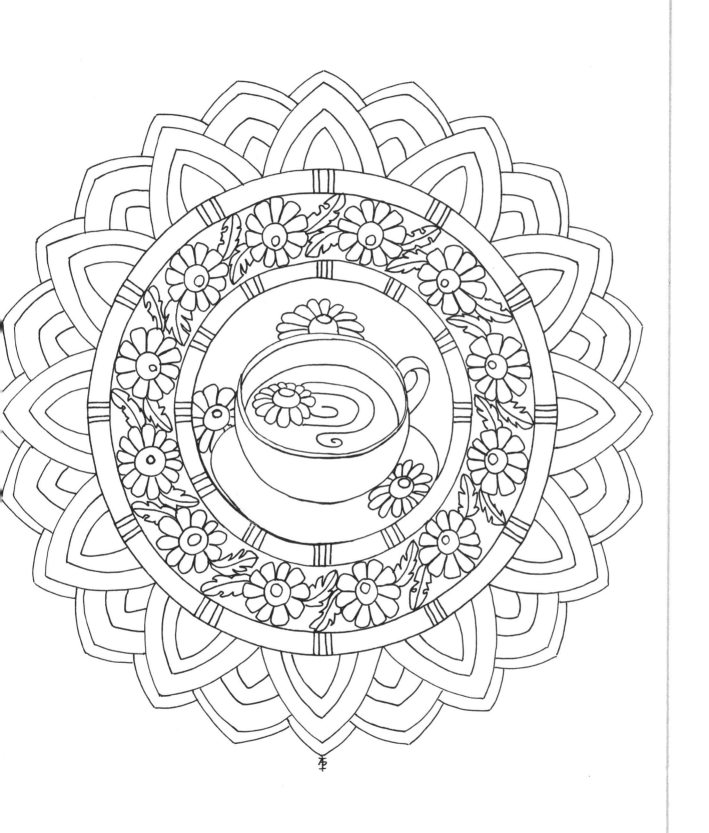

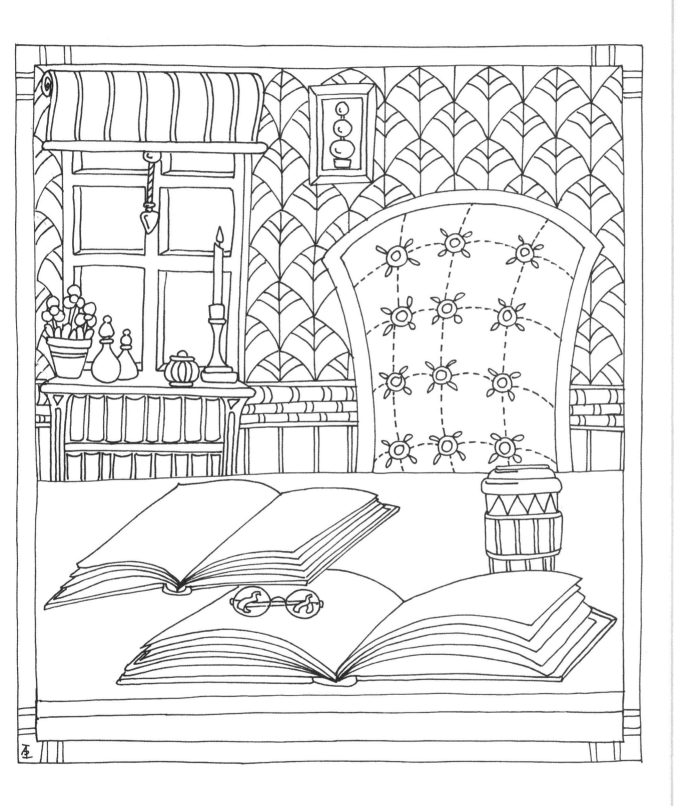

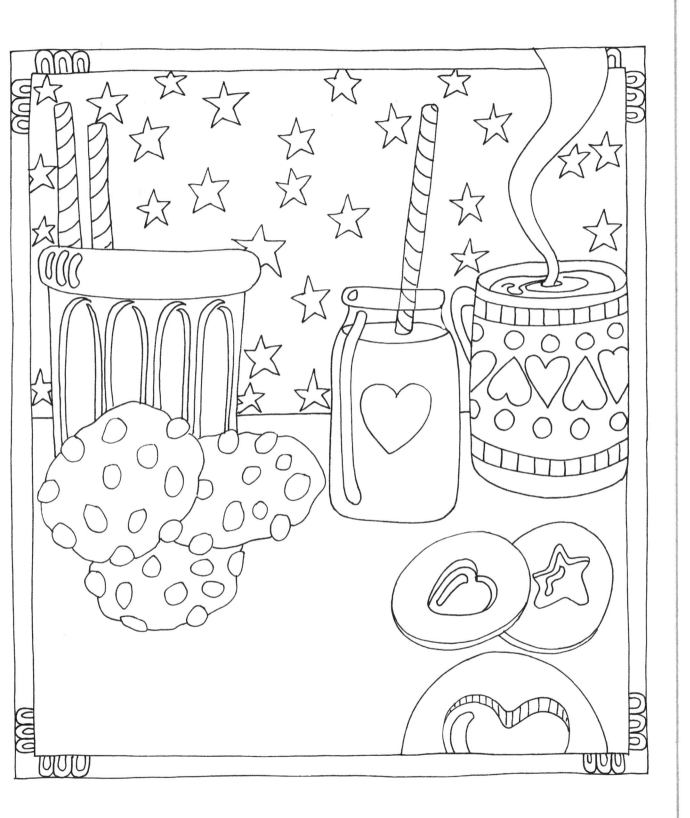

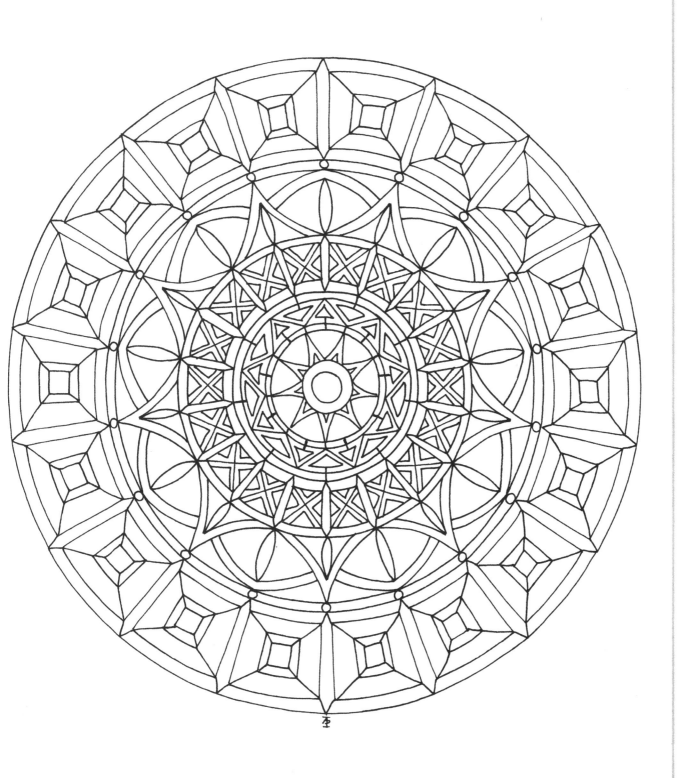

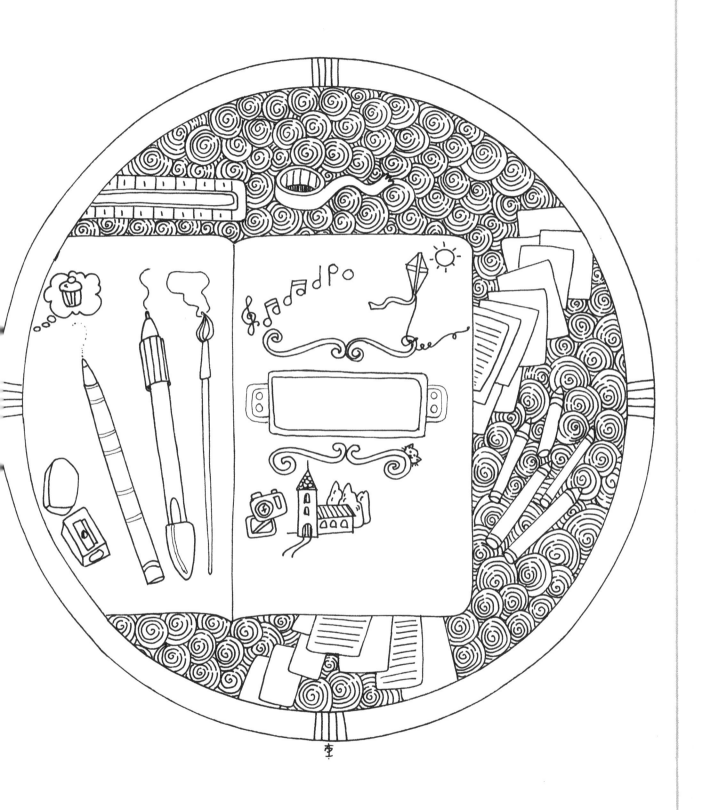

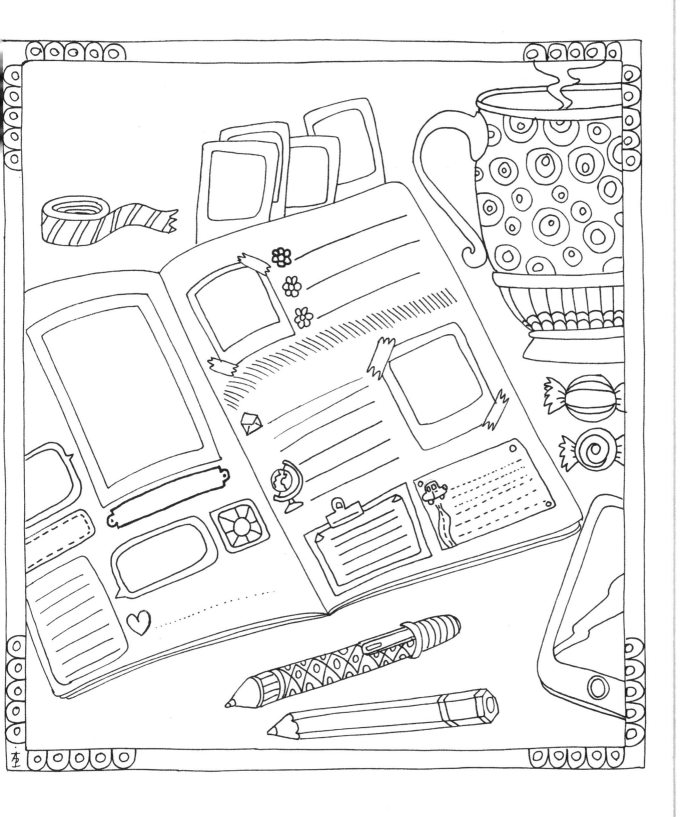

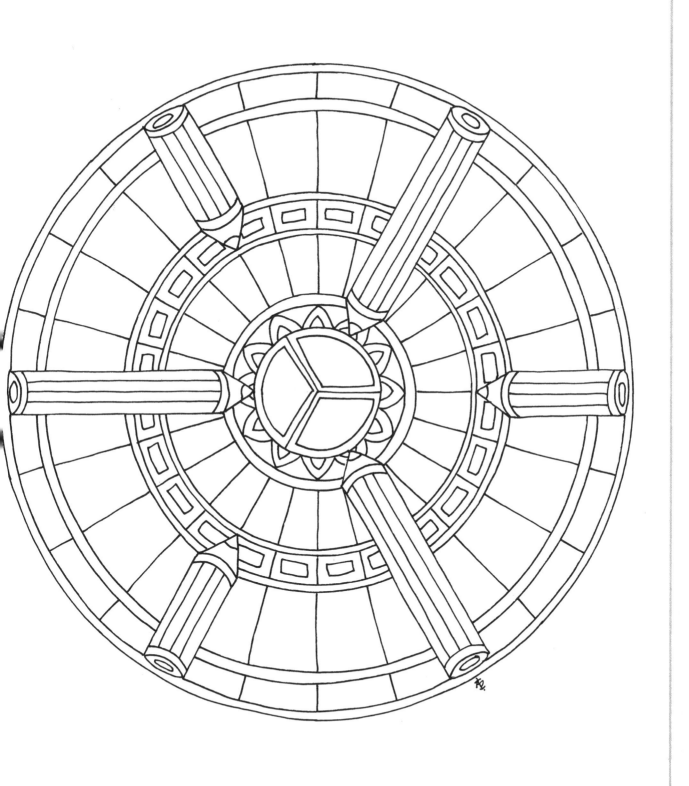

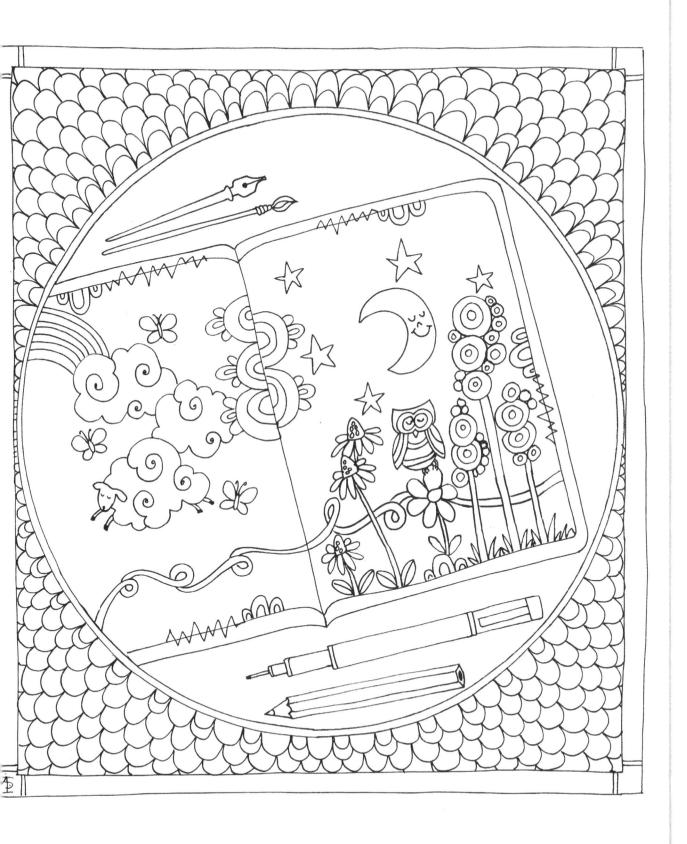

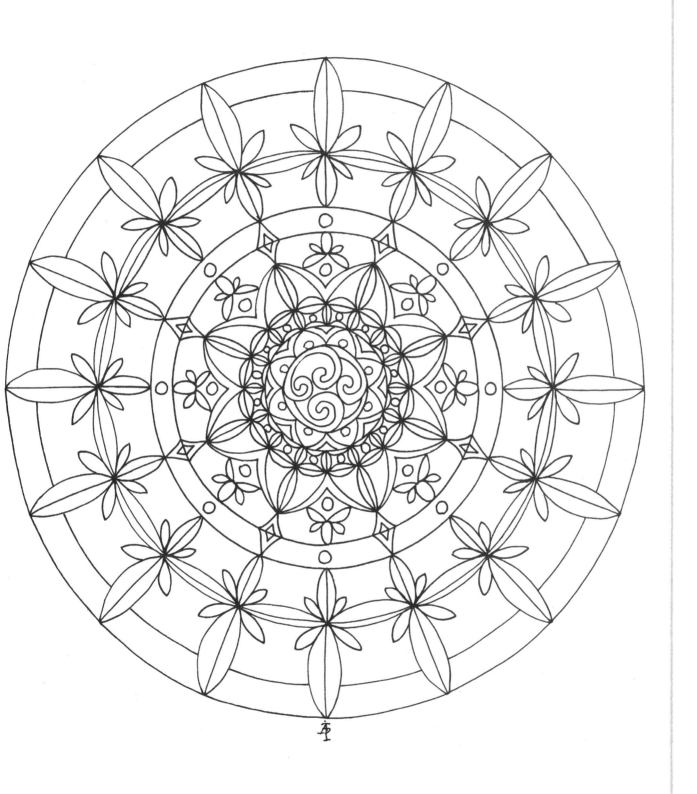

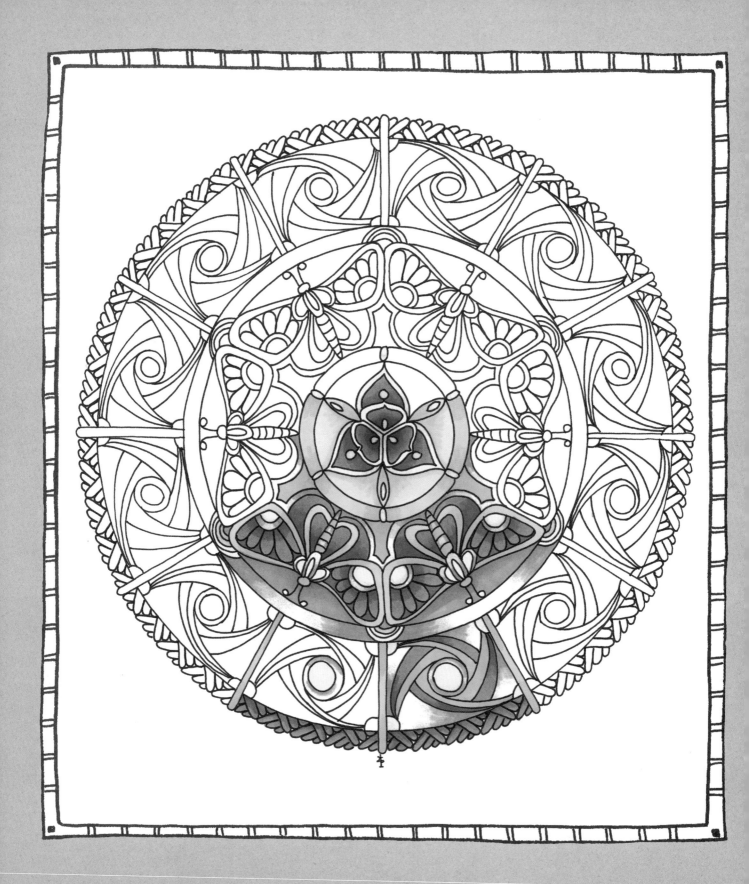

Chapter 5

SLEEP SCENES

Thinking about or visualizing scenes of others sleeping can help our brains to induce that same mindset in ourselves. As we observe the comfort and restfulness of other people—or even animals, such as our pets—that we desire in ourselves, we can help influence our minds to adopt such scenes as our own. You may ponder what allows that person or animal to be in such a serene state and perhaps discover ideas to improve your sleep habits, whether it is trying a new resting position, changing the number and type of pillows, adjusting the bedding, holding a treasured stuffed animal, or even modifying the environment. The following images allow you to try and imagine yourself in different contexts of sleep, and includes adults, babies, and animals in comfortable sleep positions in beds, hammocks, nature settings, and even whimsical places, such as on the moon, as well as nestled in blankets and with pillows. A blank panel is included at the end of the chapter to encourage you to draw and color your perfect sleep scene.

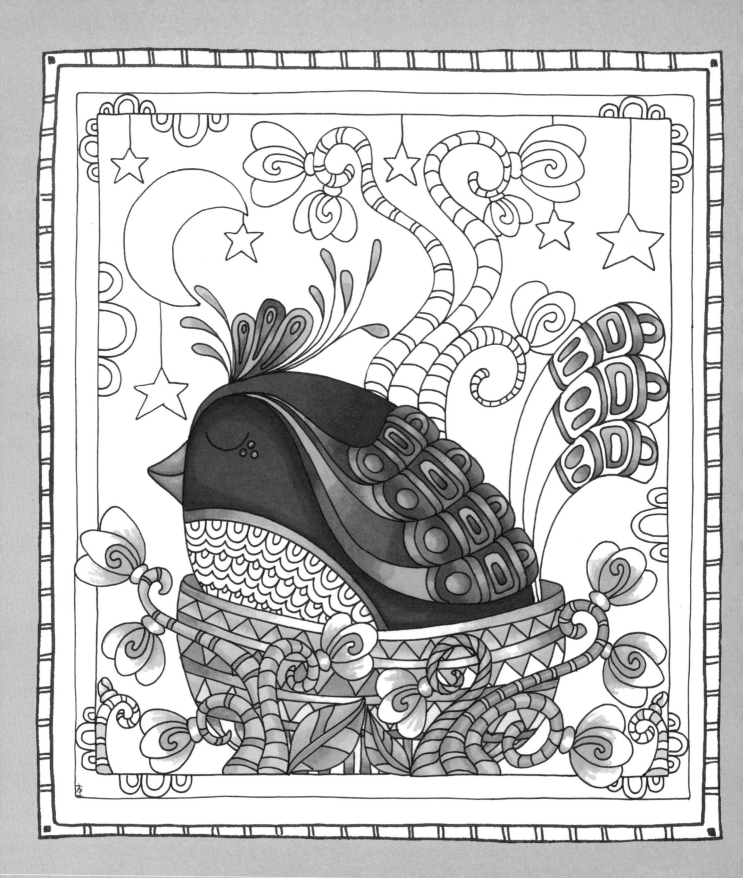

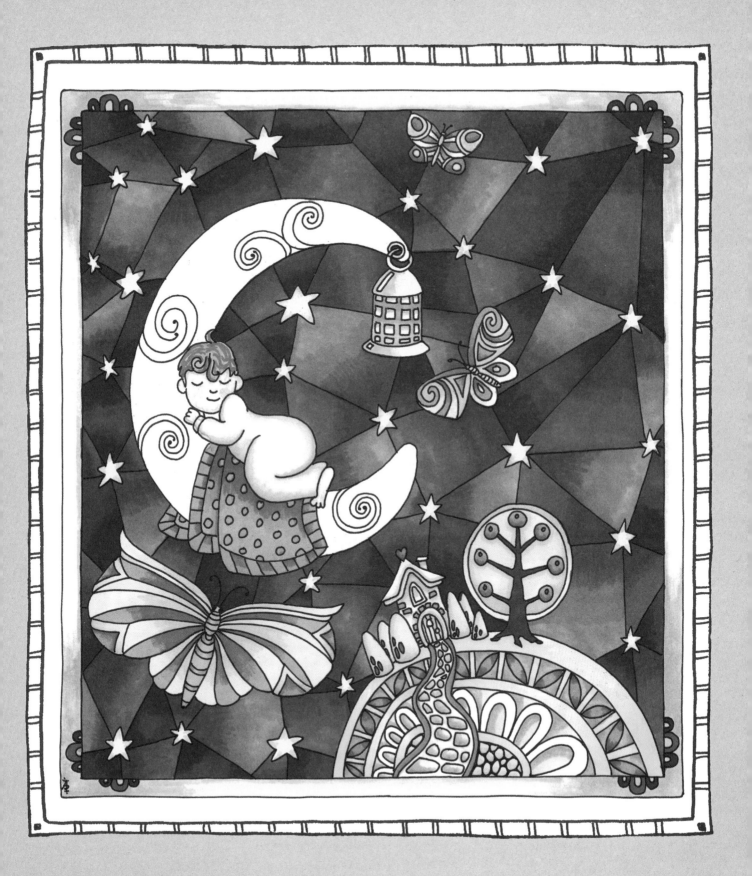

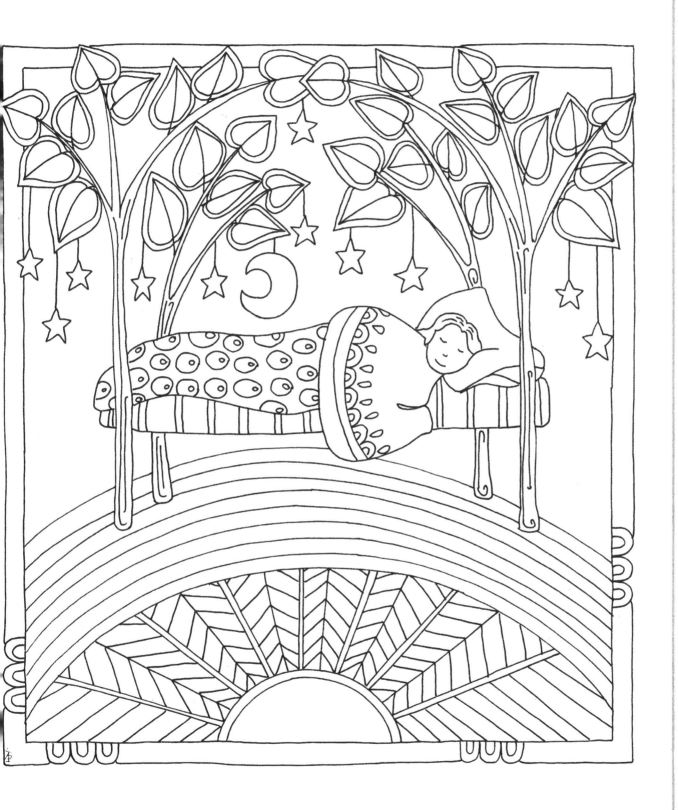

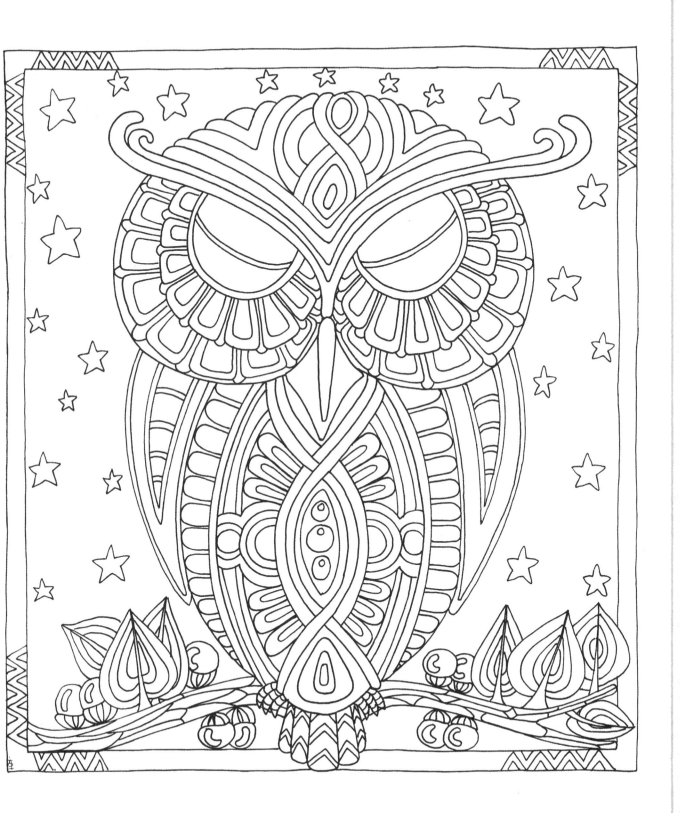

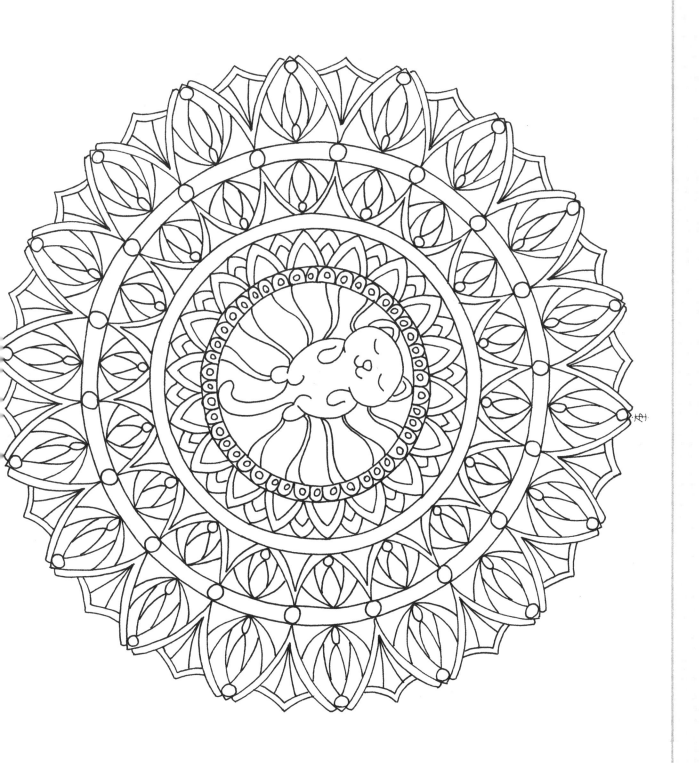

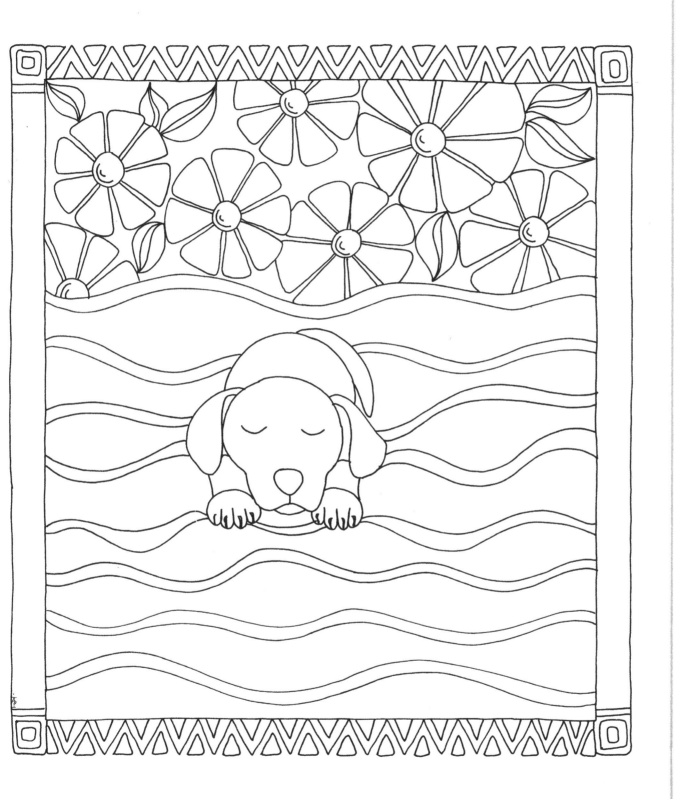

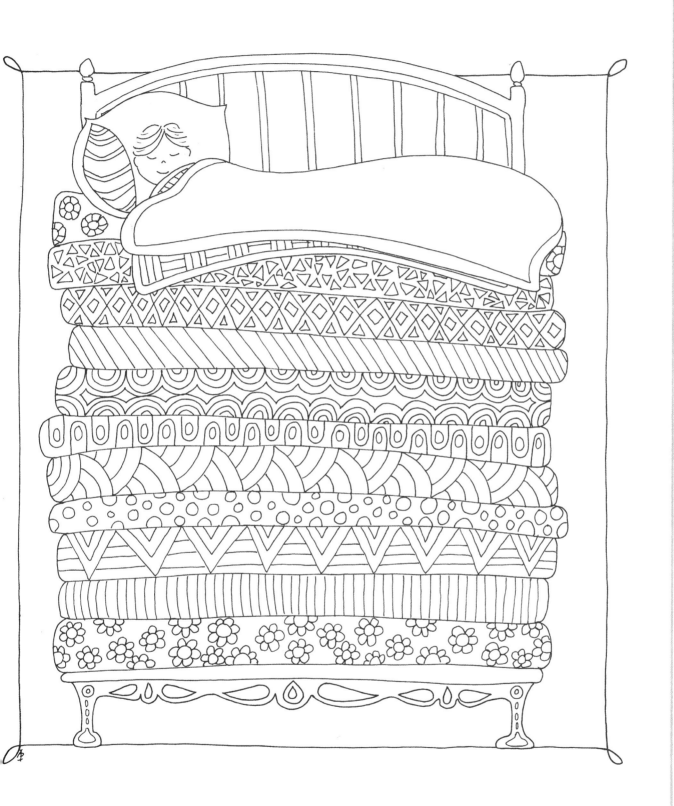

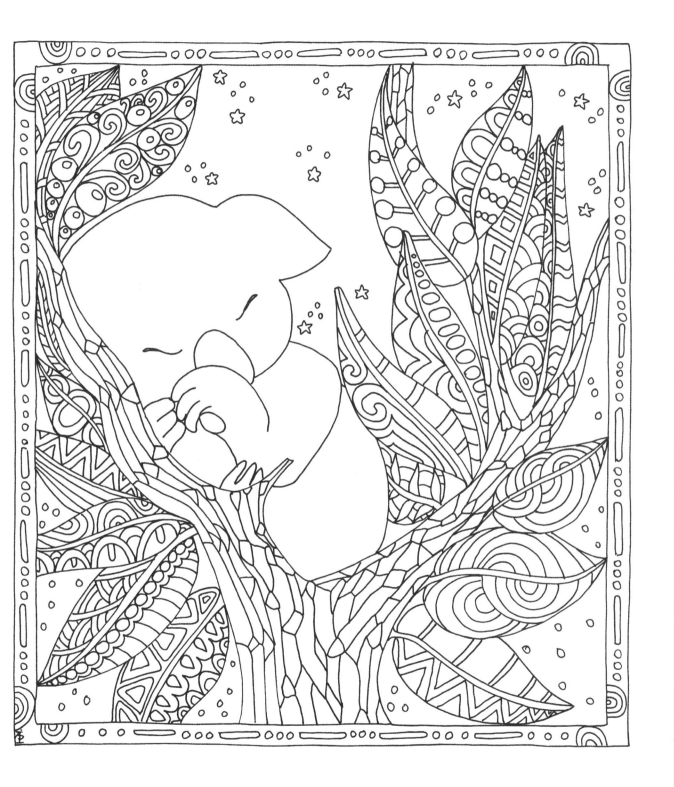

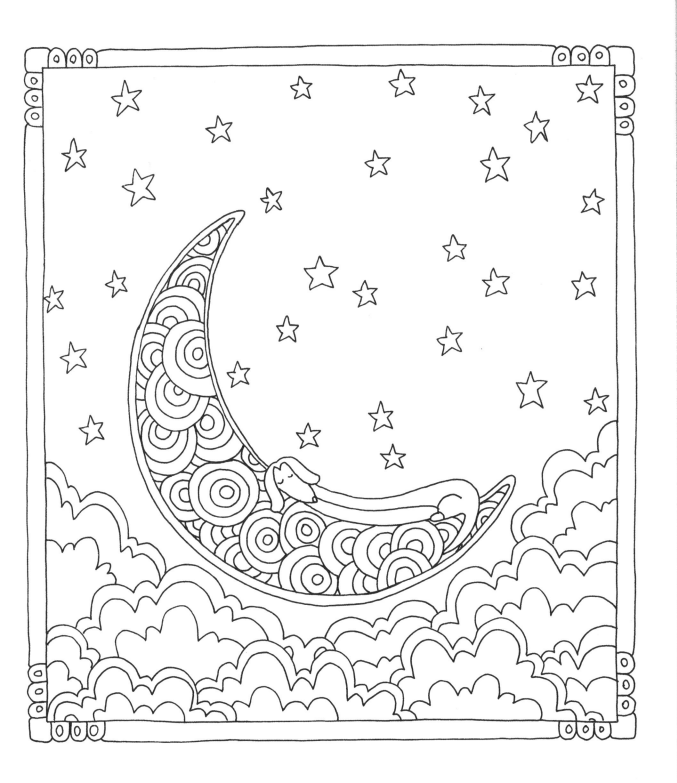

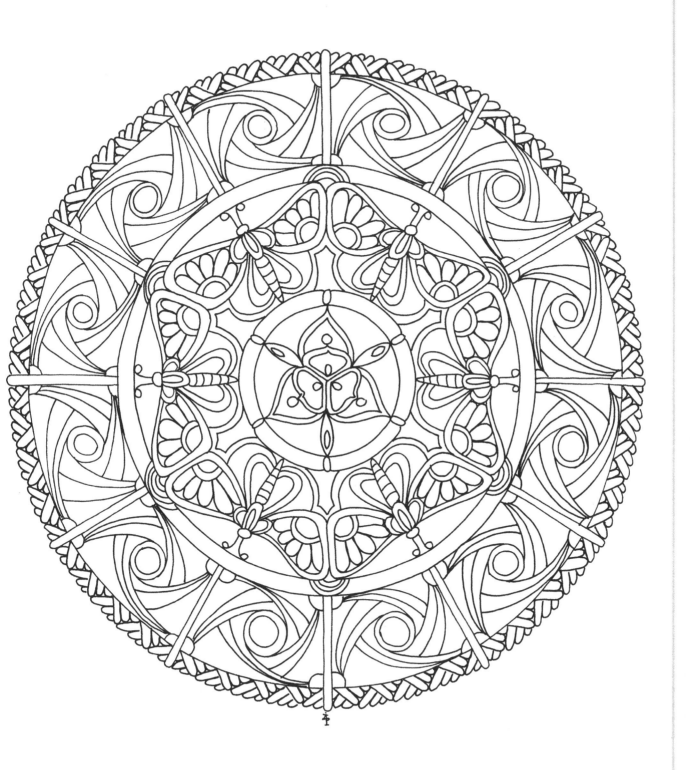

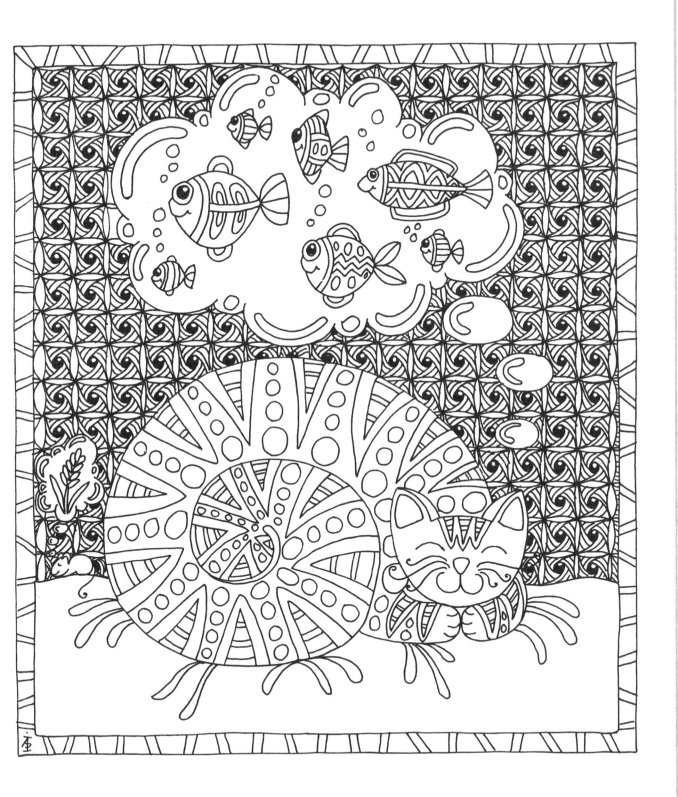

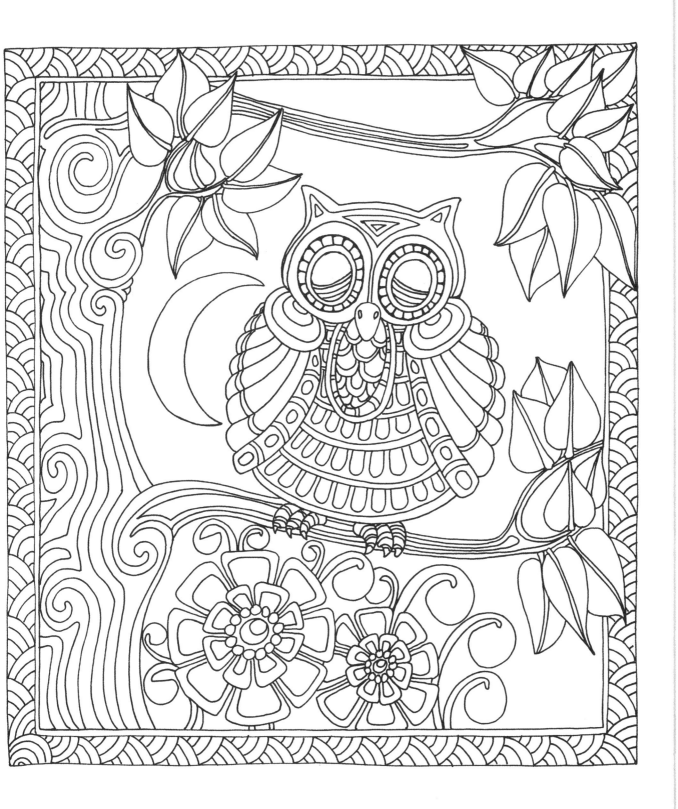

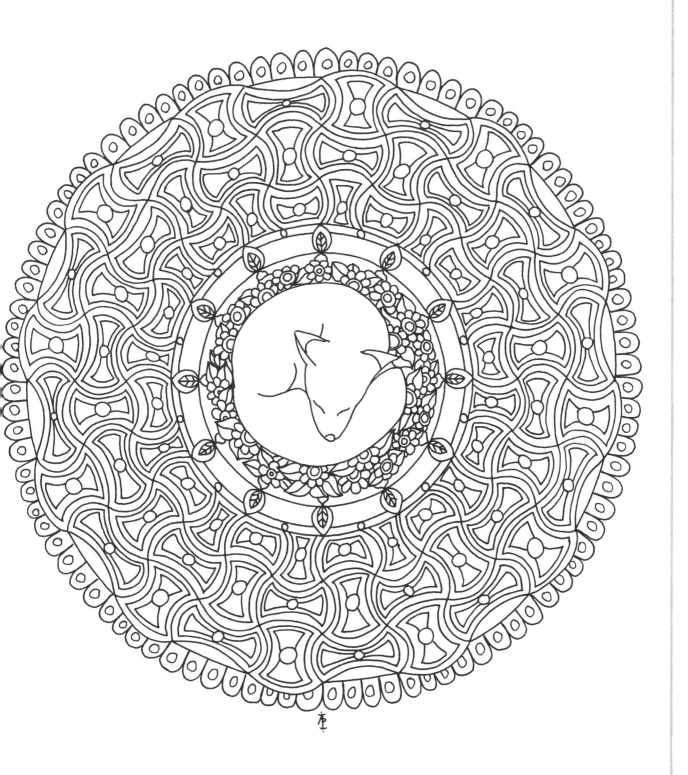

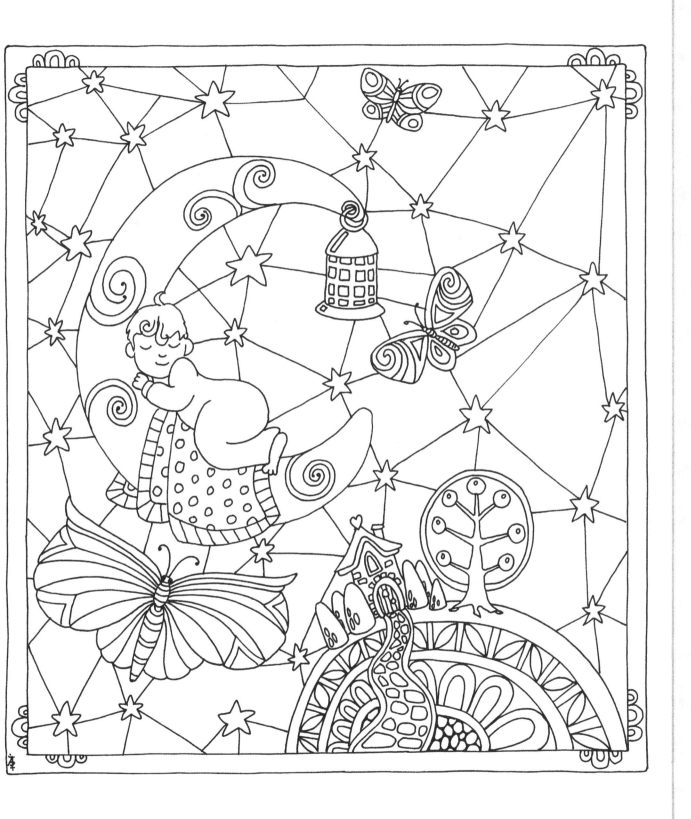

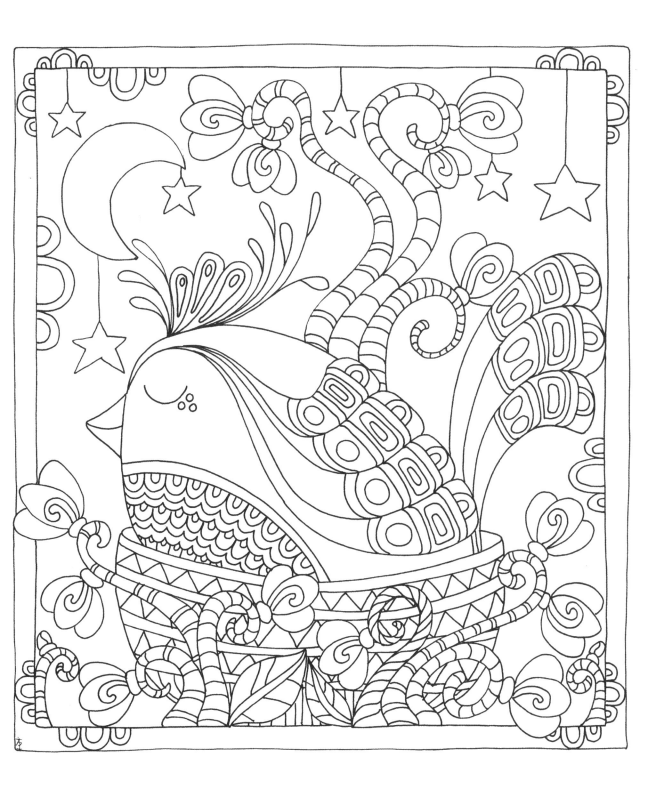

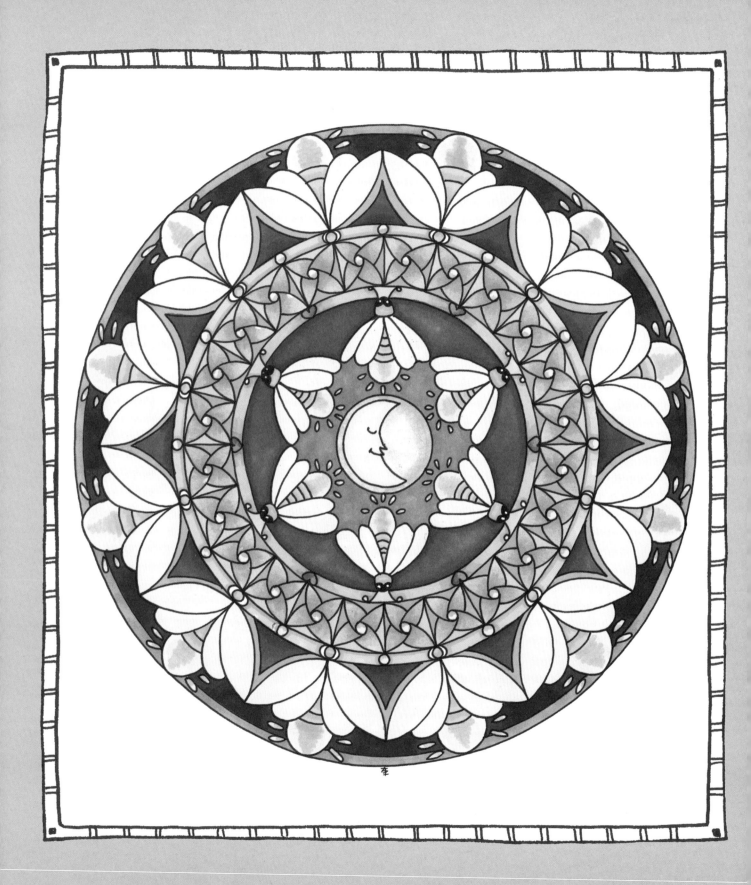

Chapter 6

FANTASIES AND DREAMS

"Sweet dreams" are what most people wish for as they drift off to sleep. The content of dreams can run the gamut in the unconscious realm, but focusing on whimsical fantasies can allow your mind to be imaginative and foster creativity outside of your everyday life, help shift your thoughts from the mundane to the fantastic and perhaps even influence your dream state. The following images can help you concentrate on positive images (with a bit of whimsy and fantasy) to set aside the stresses of the day—or even the tendency to try and solve the world's problems—and fall asleep with a calmer mind. They include nocturnal harbingers such as owls, fireflies, dream catchers, fantasy worlds and beings (think mermaids and fairies), and even the proverbial "counting sheep." A blank panel is included at the end of the chapter to encourage you to draw and color what you would like to dream about as you sleep.

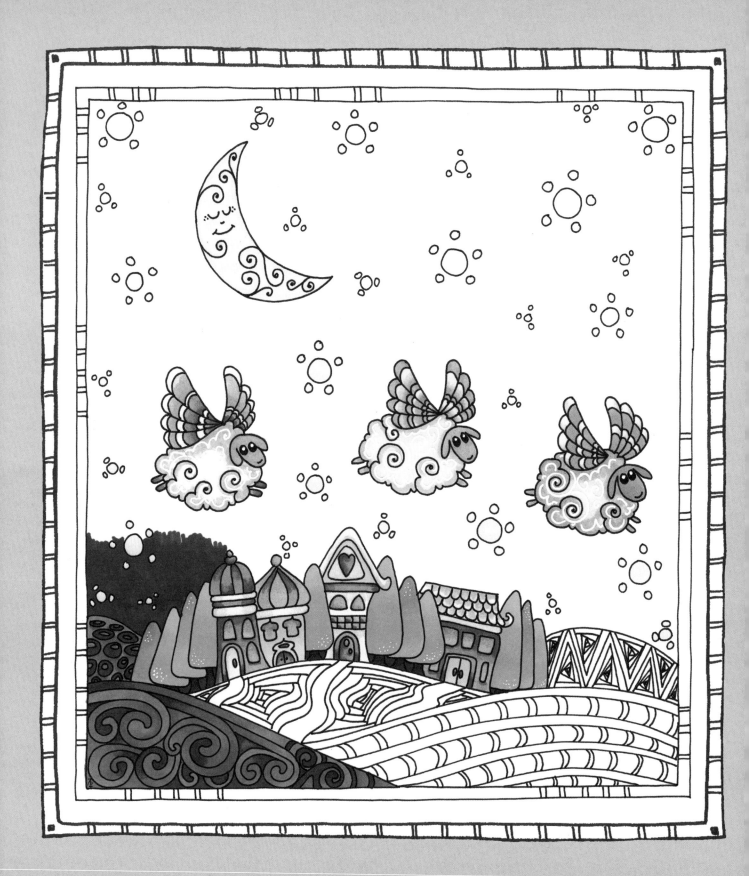

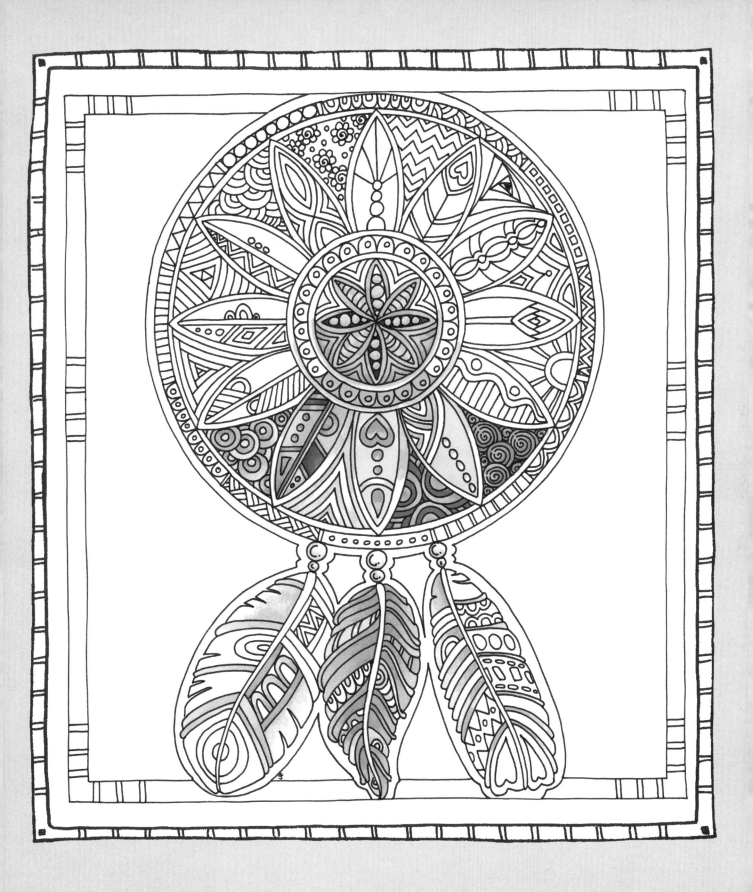

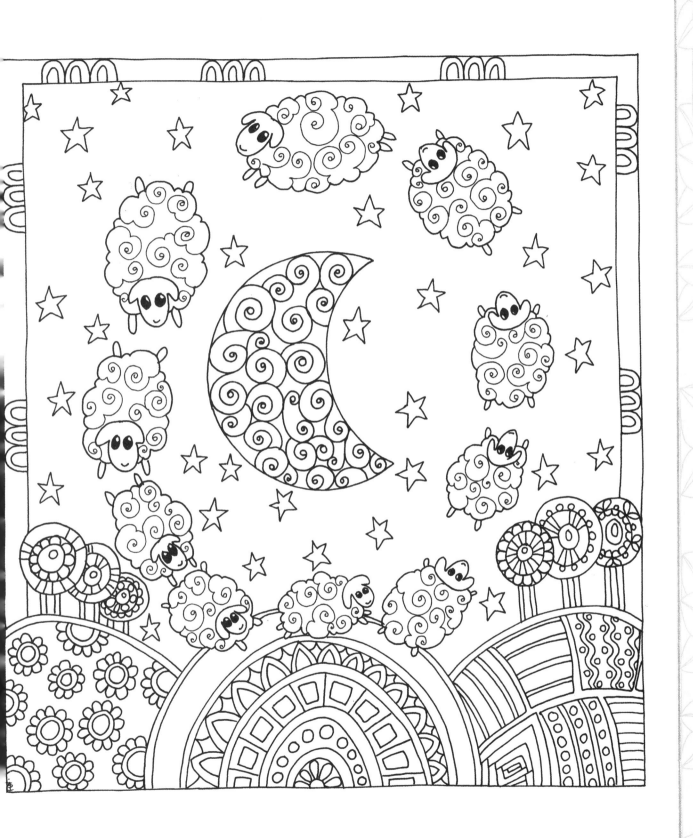

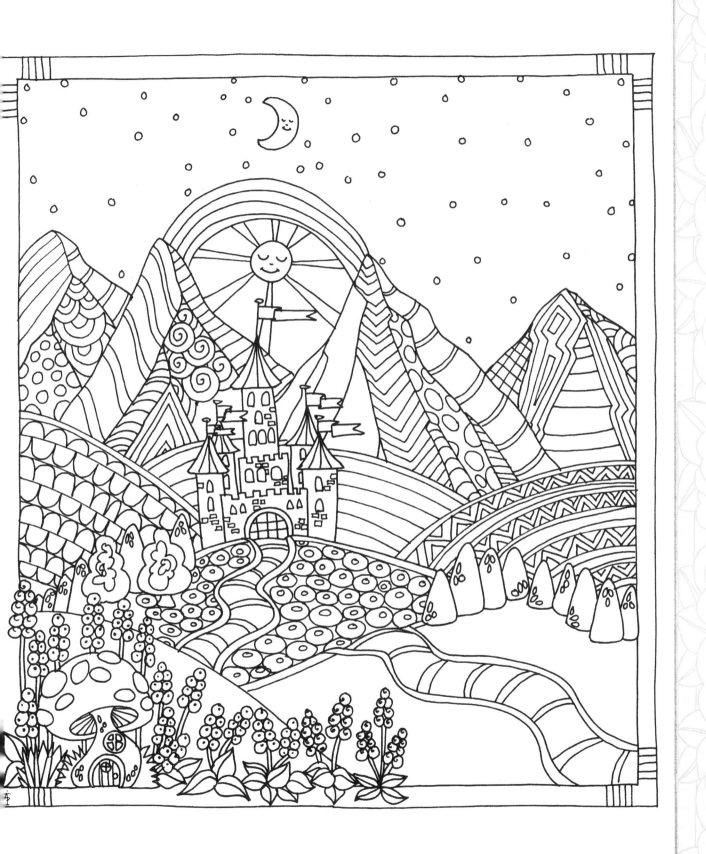

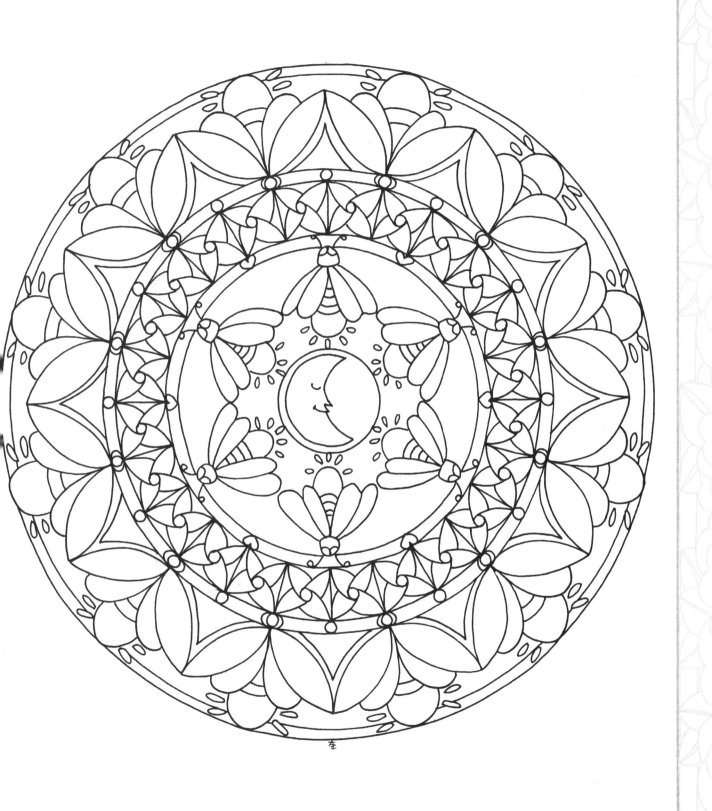

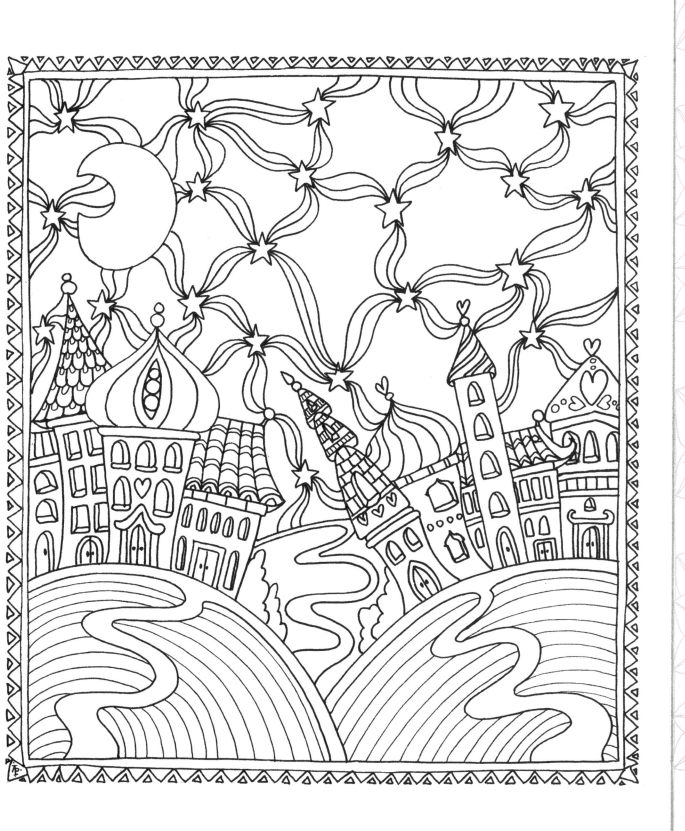

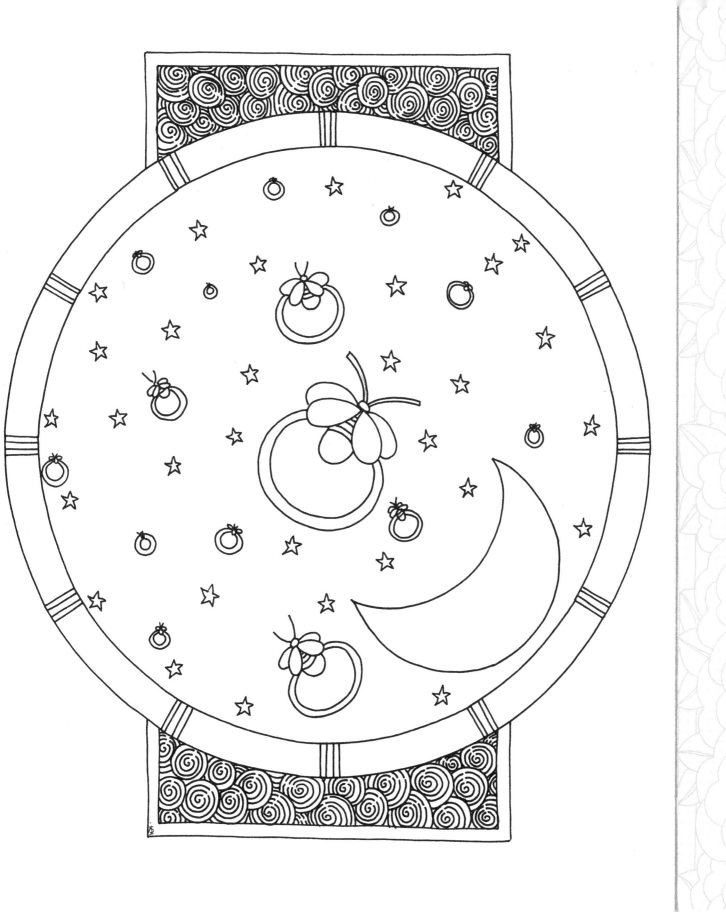

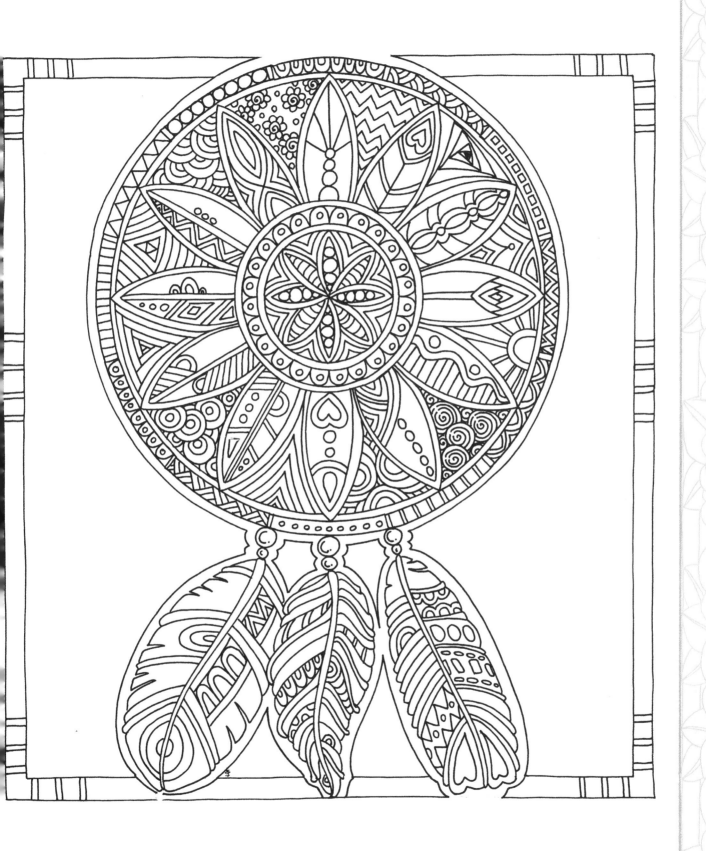

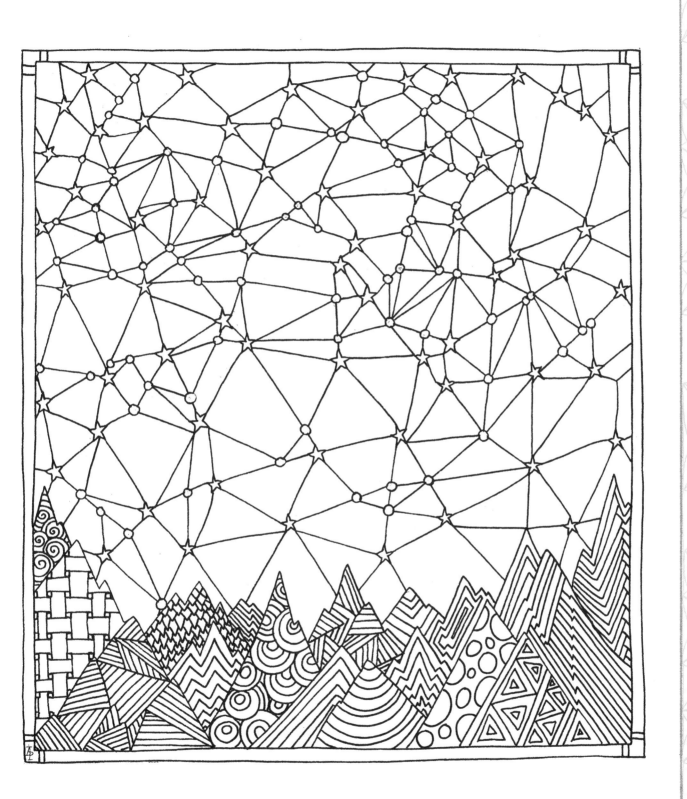

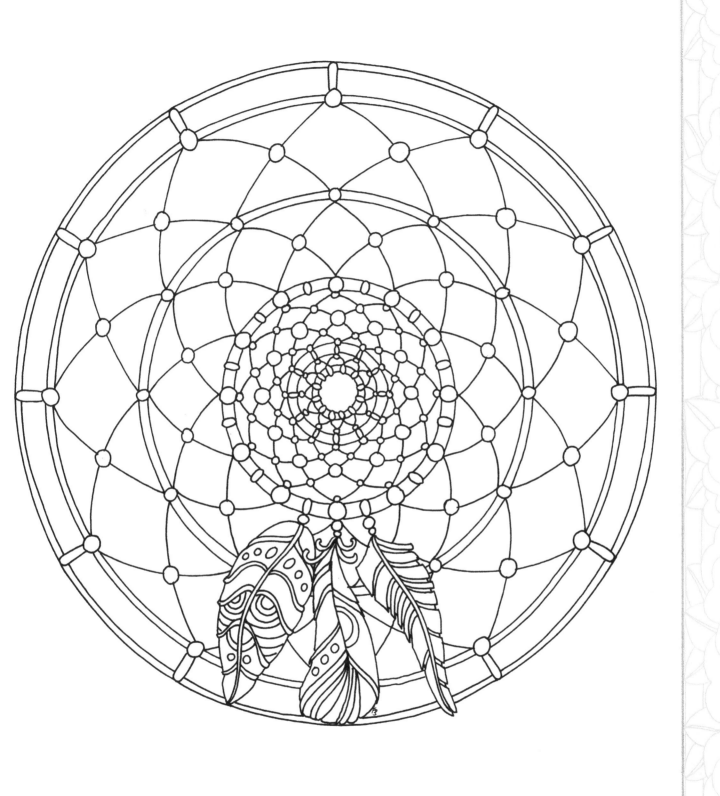

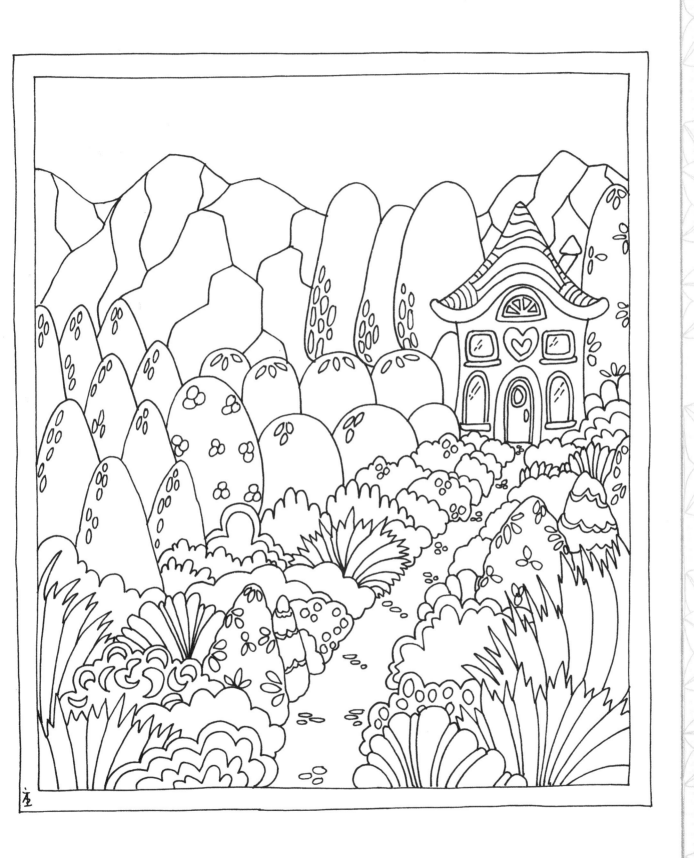

AFTERWORD

As a way to clear her mind for an hour a day, Niki, a mother whom I work with, began coloring. She told me that focusing on the colors and images made her more mindful and helped to reduce any stress that occurred during the day. It even helped her to deal with any worries she was having about the future. She is just one of many clients whom I see within my practice that are using this calming hobby to de-stress, clear their minds, and even sleep better.

As a sleep consultant, I encourage my clients to choose an activity to calm the body and mind before bed, and coloring has been chosen by many. With "Color Me Calm" being my top recommendation for clients in search of a calming activity, it makes perfect sense that "Color Me to Sleep" joins the "New York Times" best-selling "Zen Coloring" series by art therapist Lacy Mucklow and artist Angela Porter.

I am all-too familiar with the frustration that many people experience as a result of having difficulty falling asleep at night, as well as the anxiety of not being able to get back to sleep when they wake up before their alarms. After a full day of our minds being loud and busy, turning on the sleep switch can be difficult. What we do during our

sleeplessness—clock watching, flipping through television channels, surfing social media—only heightens our sleep struggle in that moment. During these times, I encourage my clients to find an activity that allows them to practice mindfulness, the art of being present in the moment. Coloring is a great tool to include in your sleep toolbox as it allows you to be present and involved in the task. While your colored pencil, gel pen, or marker gently caresses the page, and you focus on staying in the lines, you will notice that your breathing slows down and your mind quiets. In addition, coloring can take you back to your childhood, which is often associated with much simpler and stress-free times, promoting an invitation to sleep.

A good night's sleep begins before you climb into bed and having a consistent and calming bedtime routine is an important step in practicing proper sleep hygiene. Coloring can help you and your family bring back bedtime in a few ways.

TURN OFF THE TV, PHONES, AND TABLETS, AND SHARPEN YOUR PENCILS. Coloring as part of a bedtime routine is perfectly calming and a great way to practice mindfulness, which can aid in helping you fall asleep easier and stay asleep longer.

MAKE IT A FAMILY EVENT. Coloring together is a great way to encourage communication between parents and children at bedtime. Conversation will flow as you create something beautiful together—not having to consistently maintain eye contact often aids in a child feeling more inclined to stay longer and to talk more. Try doing the same with your partner when the kids are in bed!

CAN'T SLEEP? GET OUT OF BED AND COLOR. You should be sleeping 85 percent of the time you are lying in your bed. It's important to create a strong association between sleep and your bed. Doing so will help you fall asleep easier when you wake up during the night. When you lie awake in bed, struggling to fall asleep, you are creating a negative association between your bed and your sleep habits. When treating insomnia, I encourage my clients to get out of bed when they are having difficulty falling back to sleep. Take the pressure off by participating in a relaxing activity, such as coloring, and then try going back to sleep 15–30 minutes later. Setting up a coloring station before you go to bed promotes a relaxing and calming environment to help you feel sleepy and fall back to sleep more easily.

I recommend incorporating coloring into any bedtime or wakeful routine, and "Color Me to Sleep" is the perfect way to encourage healthier sleep for you and your entire family.

—Alanna McGinn,
Certified Sleep Educator, Good Night Sleep Site

Alanna McGinn is founder and certified sleep educator of Good Night Sleep Site (www.goodnitesleepsite.com), a global family sleep consulting practice. She serves on the faculty of the Family Sleep Institute and created Good Night Sleep Site after her own family's struggle with sleep deprivation. Through her education, research, and natural sleep instincts, she has helped adults, children, and employees of major corporations worldwide erase their sleep debt and achieve ultimate sleep health.